Praise for *Using Open Scenes to Act Successfully on Stage and Screen*

"*Using Open Scenes* is a unique and practical approach to scene work. As an acting teacher, I am a huge fan of assigning open scenes to my students prior to work with regular scripted scenes. This book is a guide that clearly and concisely simplifies scene work. I wish I had this book when I was an acting student. It is a must for acting students, actors, and acting teachers."
—**Malena Ramírez**, *Actress/Acting Teacher*

"What you're being provided with is the blueprint for spontaneity. As ironic as that sounds, it is the most necessary ingredient in your recipe for becoming a good actor. Imagination, intent, and then the bravery to live on stage and on screen as you do in real life . . . not knowing what's going to happen from one moment to the next."
—**Gonzalo Menendez**, *Actor*

"The unique and wonderful thing about *Using Open Scenes* as an acting tool is that it's literally a step-by-step training manual on how to successfully begin working with text. Be it scene work, or audition sides and copy, the book explains how to approach your character, without losing the emotional investment and free-form curiosity that often happens to actors when we pick up a script. It's hard to learn any performing art form from a book, yet this guide not only explains the foundation of acting and how to practice it, but it skillfully articulates how to be a better actor, rather than focusing on 'getting the scene right.' Giving many examples of how to approach your text with preparation and improvisation, the book offers practical applications to your craft without getting bogged down in wandering hypotheticals. You'll learn the important difference between 'exploring' text versus 'playing' text and how it's the audience's job (not the actor's) to figure out the story. As an actor and a teacher, myself, I am always looking for clear and concise ways to define what it is 'to be an actor,' *Using Open Scenes* not only gives this definition but presents you with countless opportunities to try

it out for yourself. I'm excited to use these valuable tools with my students and in my classes going forward."

—**Erin Roberts,** *Actor, Teacher, Coach*

"I have often used Open Scenes in my acting courses for the specific purpose of allowing actors to bring their foundational exercises to scripted work. It simplifies the process of finding the 'right scene' for everyone and allows the acting classroom to remain an equitable space where each actor's identity is welcomed and valued. I have often wished for a complete book of open scenes, crafted to allow a myriad of dramatic possibilities. And suddenly—here it is!

The magic of an open scene is the many ways it can be interpreted, so that actors have freedom to bring themselves to the work, exploring subtext, conflict, relationships, and their objectives in ways that allow them to interact truthfully.

Using Open Scenes not only clearly and concisely gives actors tools for applying their training to text, it also immediately applies these tools to the actor's daily job—the audition. Then it takes them one step further and applies them to personalizing roles in "great plays". Instead of being trapped by 'the way it's always played', actors are liberated to live truthfully inside the world of given circumstances.

The book is easy to read and digest. It doesn't ramble on, but instead immediately offers up activities for application. I love that, because the best learning comes from DOING. In an age where access is increasingly important, *Using Open Scenes* is accessible. I'll be using it in class as soon as it's available!"

—**Erin Farrell Speer,** *Director/Choreographer, Assistant Professor of Musical Theatre, UNC Greensboro*

"The examples of Open Scenes both within the chapters and index are many and varied; running the gamut from short, simple, and direct, to longer and more complex. Their purposeful lack of context will challenge the student to exercise their imagination."

—**Lisa Gaye Dixon,** *Actor/Professor, University of Illinois*

"The best meets the best—two incredible acting instructors come together in one book. I use this technique in my classroom on a daily basis and believe it to be the modern and only solid approach to Acting. Their wisdom will trickle down for generations of artists to come."

—**Brianne Beatrice,** *Actress/Acting Teacher, Northern Essex Community College*

"If you are reading this first, you must be asking yourself the same question I asked: 'Why an acting book based on using open scenes?' If you are aware of the authors, you must also be asking my second question: 'Why would two master acting teachers and directors choose to focus their collaboration on work that is usually relegated to the first level of acting classes?' READ THE BOOK. Early in the text, you will find 'You must learn to pay attention to the twinge you feel when something doesn't make sense to you.' These acting masters are paying attention to their own decades-long twinge, when they witnessed their students and colleagues struggle to activate scripted work, notes from directors, and commercial sides. On the surface, this book is about using open scenes to prevent ineffective acting work—'playing the words,' 'playing the emotion,' etc. But right below the surface of the text, similar to what a trained actor discovers when examining a scene's conflict, given circumstances, and points of view of characters, is the real objective: This book is actually a compact, complete, and current treatise on how actors can bring themselves to every role, every script, every line of dialogue. It uses the open scene to make practical the common elements for all effective other-based acting approaches. As an actor, I was reenergized by the reminders of what is essential for acting. As an acting instructor, I plan on using the book immediately. I can give no higher recommendation."

—**Scott Hayes**, *Dean, School of Communication & the Arts, Liberty University*

"*Using Open Scenes* will become the most dog-eared text in my professional and personal library. As a working professional actor and an acting instructor for university non-major acting students, the book provides extremely succinct and incisive and actionable instruction that is practical for both of my careers. The magic of the book is a lot like the magic of alive and electrifying acting: it's easy to grasp and rare to achieve.

As both a teaching tool and professional touchstone, successful stage and screen acting is easily explained in practical language and with specific examples that are accessible and understandable to novice and experienced actors. The increasingly complex open scenes are revelatory to the novice and bolster the essence of the art to more experienced, proving extremely valuable to both groups.

The mastery of the action-based acting laid out in this book is part of the lifelong learning of long-standing and working actors, and two masters of the art provide this brilliantly simple and infinitely precise and accessible road map. I'll need two copies: one for my home office and one for my faculty office."

—**Barbara Chisholm**, *Actor/Producer/Lecturer*

"*Using Open Scenes* is a gift to the actor, and to the teacher of acting. Every page not only defines the work of the actor, but how that work specifically and crucially differs from the work of the director, reader, and audience member. All of the classic ingredients in the acting 'soup' are thoroughly covered: given circumstances, conflict, point of view, objective, and action. But the difference is that *Using Open Scenes* emphasizes for the actor the transformative importance of looking at the words of the script and not making any assumptions, not one, about how those words must or should come out of you. In fact, musts and shoulds are thrown out utterly, in favor of the possible. The possible is what naturally emerges when the actor realizes it's not about themselves 'performing a story,' it's about uncovering all the things you never thought of (because they're not in that pesky script) that you could be doing to that person you're talking to, in order to change them, and that is freeing and thrilling."

—**Dan Matisa**, *Bradley University*

"*Using Open Scenes* is an invaluable contribution to the literature of acting pedagogy. Carter and Pope offer a fresh approach to action and scene work that invigorates and empowers the actor. Using open scenes of increasing complexity, this book gives the actor and the teacher of actors a fresh toolbox of powerful aliveness and presence. Beginning with a persuasive case for truly living in the moment and then providing thorough explanations for deploying the technique, the actor is able to unlock their authentic self and bring greater creativity to everything from auditions, commercials, day player, to major roles. I am excited to bring this to my students!"

—**Heidi Winters Vogel**, *BKT Associate Professor of Theater, Acting, Improvisation, Applied Theater, Wabash College*

Using Open Scenes to Act Successfully on Stage and Screen

Using Open Scenes as a "way in" to scripted material, this book establishes a foundational actor training methodology that can be applied to the performance of film or television acting, commercials, and theatrical realism.

Unlike other methodologies, this unique approach is devoid of casting considerations or imposed identity, providing actors opportunities that do not rely on nor are restricted by age, gender, race, ethnicity, regional accent, body type, identity, or other defining or delimiting aspects that come into play during the casting process. This allows the actor to focus on personal authenticity as they develop their skills.

This book will appeal to undergraduate students, acting teachers, and the contemporary actors seeking a career in film, television, or other electronic media.

Visit the companion website www.usingopenscenestoactsuccessful. godaddysites.com for additional Open Scenes and more.

Dan Carter was Director of the Penn State School of Theatre for 22 years. Previously, he was Associate Dean of Theatre at Florida State and Chair of Theatre at Illinois State, where he also served as Producing Director of Illinois Shakespeare Festival. He served as president of both the National Association of Schools of Theatre and the National Theatre Conference and Dean of the College of Fellows of the American Theatre. Acting credits include *Smokey and the Bandit II*, *Cannonball Run*, *Mister Roberts* (Martin Sheen), *Butterflies Are Free* (Farrah Fawcett), and *Richard III* (Al Pacino).

Brant L. Pope is a professional actor and director. His work has been seen Off-Broadway, in regional theatre, and in film and television. For 11 years, he served as Director of the FSU/Asolo Conservatory and Associate Artistic Director of the Asolo Theatre Company in Sarasota, Florida. He later served as Chair of the Department of Theatre and Dance at The University of Texas at Austin from 2010 to 2019. He has been the President of the University Resident Theatre Association (URTA) and is a member of Actors' Equity Association (AEA) and Stage Directors and Choreographers Society (SDC).

Using Open Scenes to Act Successfully on Stage and Screen

Dan Carter and Brant L. Pope

NEW YORK AND LONDON

First published 2022
by Routledge
605 Third Avenue, New York, NY 10158

and by Routledge
2 Park Square, Milton Park, Abingdon, Oxon, OX14 4RN

Routledge is an imprint of the Taylor & Francis Group, an informa business

© 2022 Dan Carter and Brant L. Pope

The right of Dan Carter and Brant L. Pope to be identified as authors of this work has been asserted in accordance with sections 77 and 78 of the Copyright, Designs and Patents Act 1988.

All rights reserved. No part of this book may be reprinted or reproduced or utilised in any form or by any electronic, mechanical, or other means, now known or hereafter invented, including photocopying and recording, or in any information storage or retrieval system, without permission in writing from the publishers.

Trademark notice: Product or corporate names may be trademarks or registered trademarks, and are used only for identification and explanation without intent to infringe.

Library of Congress Cataloging-in-Publication Data
A catalog record for this book has been requested

ISBN: 978-1-032-15087-1 (hbk)
ISBN: 978-1-032-15090-1 (pbk)
ISBN: 978-1-003-24244-4 (ebk)

DOI: 10.4324/9781003242444

Typeset in Times New Roman
by Apex CoVantage, LLC

Contents

	Foreword by Richard Robichaux	x
	Introduction: You're On, and It's All on You	1
1	Acting and Performing: The Difference Between the Two	6
2	Open Scenes (Without Context): Finding the Action	18
3	Investigating the Script: Give Me a Place to Stand On, and I Will Move the Earth	29
4	Open Scenes Applied to Commercial Copy: Booking the Spot	36
5	Open Scenes and the Day Player: Film and Television	48
6	Problem Solving With Open Scenes: Using Open Scenes to Address Specific Problems in Scenes From Dramatic Realism	66
	Open Scenes	87
	Appendix	107
	Index	109

Foreword

From high school to Hollywood, you'd count it one of the thrills of your career to just sit in the room with two titans of business and hear them discuss what makes a scene a scene, what makes work . . . work. Well, I've been lucky enough to be in that room with Dan Carter, when he was my boss at Penn State where he was the longtime chair of its storied drama program, and with Brant Pope, a nationally recognized leader in actor training, who recommended me for that job. This book reminds me of how many times I've sat and just . . . talked about acting with them! Now with *Using Open Scenes* they have opened the door to their conversations by creating an exciting approach to open scenes. They systematically made a fast and clear teaching tool for anyone interested not just in acting . . . but in acting better. They hit home over and over again the truth that it's not about getting it right or wrong. But it is about getting better, whether you're in high school or on set. The modern actor needs to have real agility and speed when it comes to approaching work in the 21st century. Now one must be able to quickly understand commercials and new media while also be at the ready for a 5-line role on television, the lead in a movie, or the warrior in that reimagined classic play they're doing down in the park this summer.

So how can you train your instrument to be that flexible and still bring a sense of aliveness to the work? How can you bring your unique point of view to work you didn't write or work that doesn't connect with your own backstory? And even harder, how do you teach how to do that in a modern classroom? These pages truly do break it down for you, in a step-by-step process. Whether they are guiding us through Pulitzer Prize winning scripts, commercials, or their brilliantly composed open scenes, you always feel Dan and Brant treat each word, each line, each relationship, and each point of view with a deep respect for the mysterious craft of acting. You can feel their reverence for what an actor brings to the story. After all, we are not storytellers as they say, we are story DOERS. We've got writers and designers and directors to tell it. We get to do the story.

For too long, actors have felt in their scene classes that they haven't been able to DO their own stories because the scripts were closed off to them in too many ways. For many young actors, scene work has felt closed to them as they have searched over and over to find a scene to "work" on that really fits them. This is why Dan and Brant's technique comes at just the right time. In this open classroom, with this open scene technique, every story fits. *Using Open Scenes* is a room for everyone to not just do the work but do it better.

"Splendid possibilities are open to us." The great Polish poet Ana Swir ends her poem *I talk to my body* with this hopeful exclamation. I wish I could be in the room to see where the "splendid possibilities" take you in these scenes. You've got a couple of master teachers to help you along. So turn the page. Class is now open.

Richard Robichaux currently plays George in David E. Kelley's BIG SHOT on Disney+. Recent credits include OCEAN'S 8, WHERE'D YOU GO, BERNADETTE?, and the upcoming CHARMING THE HEARTS OF MEN with Kelsey Grammer. He is also known as a frequent collaborator with Richard Linklater, including the Oscar-nominated film BOYHOOD and cult-hit BERNIE. In addition to his numerous TV and film credits, he has worked at many of the best theatres in the country including the Mark Taper Forum, Yale Repertory Theatre, and Shakespeare Theatre Company to name just a few. He is also a passionate advocate for arts education and has taught at many of the top training programs in the US, including UC San Diego where he holds the Arthur and Molli Wagner Endowed Chair in Acting. Richard is a frequent guest at high schools, colleges, film festivals, and conferences across the country.

Richard Robichaux

Introduction
You're On, and It's All on You

The intent of this book is to provide a practical and effective approach to work that pays off in performance; to help the actor avoid the common pitfalls of playing the problem, playing the words, telling the story, or playing the end of the scene. This approach focuses on developing a way of working that will allow the actor to play action in the immediate and specific circumstances conceived by the writer, embodied by the actor, and guided by the director.

* * * * *

Interviewer: "Did you have to prepare for this role other than just learn your lines?"

Peter O'Toole: "'Other than just learn your lines.' Just think of what you said. . . . It's not easy. It takes a long time. The old-fashioned word for it was *study*. You go alone. You have no observer. No interlocutor. And unobserved, uninhibited, private study is the backbone of any fine actor or actress. . . . What made it so spontaneous-seeming, which is what we're supposed to do, what made it so electrifying in its naturalness was the fact that it was so completely rehearsed."
<div align="right">—(Interview available on <i>YouTube</i>) www.youtube.com/results?search_query=peter+o%27tool+on+charlie+rose</div>

* * * * *

The authors have become more and more reliant on open scenes in both acting and directing classes because we find they are useful in avoiding the baggage of preconceived notions that often accompany scripted material even—or perhaps, especially—when students engage great scenes by great writers. Open Scenes can stimulate the actors' curiosity and imagination in ways other material often does not precisely because the actor understands

DOI: 10.4324/9781003242444-1

that they are not overshadowed by the innate demands of the material ("Hamlet must. . ."; "Hedda would never. . .") They understand that they must make the most of what is given to them by finding the dramatic action and *bringing the scene to life*, and they know they must do a great deal of this work on their own, independent of director, dramaturg, dialogue coach, or other actors precisely so they can ultimately be responsive to all those dynamics when they arise. **Because Open Scenes are devoid of context, given circumstances, and character specificity, the actors must uncover whatever meager clues the text provides and employ their imagination and creativity to find "playability."** It is up to the actor to make something of the text rather than rely on the text to do the heavy lifting.

Open scenes also help us avoid the ever-increasing role *identity* plays in our personal lives; that is, they eliminate specific aspects of certain characters that lead some actors to not want to play them. For example, a Latinx gay man may wish to play only Latinx gay men at a particular time in his life, or he may wish to play a broad range of roles and avoid *identity typing*, even self-imposed. These are personal decisions completely outside the purview of this book, the purpose of which is to explore the craft of scene study, because those skills will serve you well regardless of the line of roles you wish to pursue. Open scenes can remove the obstacles to your growth and also eliminate a script's demands as a distraction to your work. They require you to investigate the text with fresh eyes.

* * * * *

The authors believe that most actor training sequences begin with improvisational work. By this, we mean that Acting 1 class doesn't usually begin by jumping into scenes from plays. Rather, it is concerned with first establishing a foundation that defines for the students what constitutes the art of acting. What is acting and how is acting taught and practiced? These questions are most often addressed by creating improvisational exercises that introduce the student actor to what it means to behave truthfully in an imaginary set of circumstances. Well-established improvisations teach the actor to behave with clarity and purpose on stage and reinforce the concept that acting is pretending truthfully. More advanced improvisational exercises involve another actor and teach the student to pay complete attention to the "other" and to listen and react to what the other person is saying. With no lines to memorize, no set blocking to execute, and no predetermined outcome, if one enters the scene with a point of view and a goal and remains tuned in to their partner, even an inexperienced actor has a fighting chance to respond truthfully to what she encounters within the scene, giving the teacher the opportunity to build on successes from the beginning as well as to identify and convey where growth is needed. Even more important, the

novice actor is able to experience success. Often this improvisational work takes an entire year of study to allow the actor to behave honestly without self-consciousness or awareness of being observed by an audience. To the consternation of acting teachers, this truthfulness, purposefulness, and clarity of behavior are frequently lost when the transition is made to scripted work. This book uses Open Scenes to help combat this propensity.

What lies between the freedom of improvisation and the requirements of text is the frequently agonizing transitional stage wherein students must make the "big leap" and come to terms with the necessity of saying specific words and perhaps performing specific activities. While, there are countless articulate approaches to both these stages of training, it is in the transitional phase where too often we rely on a miracle occurring, and too often the lessons learned during improvisation do not transfer into working from a script. Frequently, the magic an actor captures when working in improvisation mode is lost when he is confronted with the demands of text. Suddenly, his imagination becomes stunted as he tries to match what he thinks he *should* do or to repeat *what worked last time*.

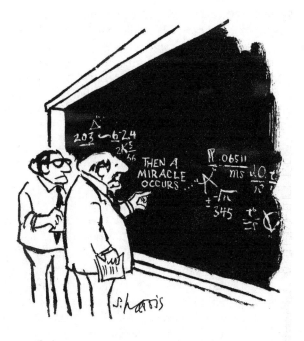

Figure 0.1 Cartoon by Sidney Harris © *

The purpose of this book is to "be more explicit in step two" by helping actors understand that the goal is "preparation followed by improvisation," and that the ability to improvise while performing scripted material can be learned and must be earned through preparation, meaning intensive study of the given text.

* * * * *

Many teachers find it helpful to assign a common text in order to allow the entire class to collectively address the challenges of moving into text. This impulse is excellent, but finding a text that works for every individual student is virtually impossible. In addition to explicit given circumstances that may militate against each student fully embracing the work, there is also the potential baggage that a full script brings to bear on the class. **Etudes such as these Open Scenes provide opportunities that do not rely on nor are restricted by age, gender, race, ethnicity, regional accent, body type, identity, or any other delimiting aspects that often come into play during casting considerations**. Therein, they provide opportunities for everyone in class to analyze the text for clues, interpret the text creatively, and bring their work to life in the studio while maintaining and **working from their personal authenticity**. Open scenes also allow for more effective coaching, because teaching scene work often devolves into directing, giving notes to make the scene "better." In those cases, the scene may improve greatly, but the student won't necessarily learn much to help him with the next scene. Everything about this approach has to do with becoming a better actor, not "getting a scene *right*."

* * * * *

The principles expressed in this book should prove useful to any scene study and should be applied to each scene in which an actor appears; however, **they will be especially helpful to the Day Player on a film set,** because open scenes are self-contained and finite. Just as is usually the case with the *side* presented to a Day Player, there is no previous scene to build on and no reason to hold anything back for a more dramatic scene later in the script. Nor is there any clear backstory. Also, it's likely that the Day Player will not be given the entire script but will only see the pages in which she appears. In that regard, the work required by open scenes is directly parallel to the work of the Day Player and is great preparation for the way most actors break into the film industry. In addition, the increasingly common practice of **self-taping auditions** makes the actor even more responsible for doing the actor's work on their own in order to demonstrate not only what you would bring to this role but also that you are, after all, an accomplished actor.

When this practice is mastered, the Day Player can feel confident walking onto a set filled with those who have built up the camaraderie and momentum, and shared knowledge, experience, and understanding that come from working together day after day either for weeks on a film set or even years on a series. Having done this work, she will be confident because she knows she is prepared and is ready to "take the stage" with the leading actors, matching their commitment during the limited time available. To put it another way: when you only have one day (which may really be only one morning), you have no time to waste, especially when your acting partners have responsibilities for scene after scene, day after day. **Preparation is key, and this book provides the keys to preparation**.

The skills in this book will help you show up confidently and ready to work. Having done your homework, you'll be ready to respond to what actually happens on set and to any new information or direction that comes your way. While time and the demands of production may limit the opportunity for your colleagues to acknowledge your good work, you will develop a reputation as a reliable and valuable actor, a good person to have on the team.

1 Acting and Performing
The Difference Between the Two

The Performer as Storyteller

Of all the things we have said to actors over the years, the one that probably causes the most looks of surprise is when we tell them that they can never be the storyteller. To them, this seems contrary to what they assumed acting was. So, we explain to them the difference between acting and performing. When we call them performers, we mean that the artists on the stage are operating in the same reality as the audience. This could be a solo performance like standup comedy or a play such as Anna Deavere Smith's *Notes From the Field: Doing Time in Education*. In this work, Smith employs a journalistic approach in which she interviews members of a particular community in search of the reasons why there is a pipeline between school and prison. She then tells their individual stories to the audience in her performance. She is, in effect, the storyteller and like a musician, she is "performing" her play with a direct relationship to the audience. Because she is the storyteller and existing in the same reality as the audience, we call what she is doing is "performing."

The same can be true for a performance with many people in it. When director/creator, Will Davis speaks of his production, *Bobbie Clearly*, it is obvious that he is constructing a performance piece. Again, by a performance piece, we mean a theatrical endeavor where the artists on stage are themselves the storytellers and they relate directly to the audience. They are *performing* for the audience as part of telling them the story, or perhaps confronting the audience with the sociopolitical significance of the piece. For Davis, this production was a documentary-style work, playing out like the filming of a documentary. The story is about a boy who shoots a girl in the middle of a cornfield in a small Nebraska town. What makes it a performance piece is that the artists on stage are primarily engaged in direct address to the audience. Director Davis wanted a town hall type of space and the feeling that the audience and the performers were "all in this together."

DOI: 10.4324/9781003242444-2

What differentiates acting from performing is the purpose of the theatrical art object and the function of the artists on the stage. In realism and naturalism both in the theatre and in film/television, the people on the stage or on the screen are behaving truthfully in an imaginary premise different from the reality of the audience. There is no direct relationship with the audience and in fact the premise of the form is that the audience is watching people on stage who are unaware of their presence. They are not the storytellers rather we call them actors (instead of performers) because they are required to adopt the psychology and behavior of a fictional character in a pretend reality and behave as if it were true. The people they are impersonating are called the characters, and these people have no idea that they are in a story. So, whereas the performer is the storyteller, **the actor can never be the storyteller**. In fact, one of the most difficult aspects of training an actor is to teach them to never play the story. One of the reasons this is so difficult is that the actor KNOWS the story as soon as she reads the play. The story is right there in the script. But what happens if the actor (who knows the story) allows her character to know the story? The character would suddenly have mystical, psychic powers allowing them to know what happens in the future. This is one of the greatest challenges in acting: the actor must always know the story, but his character can never know the story.

It is important at this point to note that there are numerous examples of realistic plays that also use direct address to the audience in the script, or "breaking the fourth wall," as it is called. In otherwise realistic plays, many writers use elements of direct address such as asides and monologues to the audience as a tool for telling the story. In some plays or films, one of the characters may literally serve as an omniscient narrator; however, when performing their actor function, they must revert to the reality discussed here; which is to say they must behave truthfully and only with such knowledge as they had at the time the scene actually occurred. For example, in her wonderful play, *How I Learned to Drive*, writer Paula Vogel alternates realism with scenes featuring a male and female, Greek-like chorus to comment on the action of the play. So, it is not our contention that a play is either complete realism or something else. Rather, that we are focusing our concern on the situations when the actors on the stage are impersonating social reality by engaging and living in an imaginary world different from that of the audience. Since Henrik Ibsen began writing his great realistic plays in the 1870s, it has been obvious to theatre artists that special training was needed to learn how to work in these kinds of plays. Inspired by Russian director, Konstantin Stanislavsky, generations of acting teachers and numerous acting methodologies have tried to address this duality of actor and character. **This book uses Open Scenes to provide an interesting new way to solve this problem.**

Conversation in a Restaurant: A Story Appears

Recently, one of the authors of this book was sitting in a booth on the other side of a small glass divide that separated him from a married couple. Despite his every attempt, it was impossible not to overhear the conversation between them (as if eavesdropping through a fourth wall), especially since it became heated and rather dramatic. The issue was whether the wife would quit her job to be a stay-at-home mother for their young child. The contention, at least on the surface, was over the financial impact of this decision. The husband was insistent that this would bankrupt them, and his spouse was equally passionate that the child needed to be with his mother and not raised by strangers in an expensive and distant daycare.

The encounter had all the ingredients of a scene from a play. First, there was something tremendously important at stake; namely, which is more essential, the financial health of the family or the well-being of their child? Then, there was a conflict in that both of them were deeply invested in changing the perspective of the other. This conflict, called **dramatic action** in the theatre, allowed the unintended audience to learn a tremendous amount about these two people that would have been impossible had the author simply overheard them talking about a movie they saw or which kind of car they want to buy. In other words, this was precisely the kind of scene a writer would choose to include in a script.

Because the subject of the argument was so critically important to each of them, they both brought every element of their personality to bear in order to win over their partner. In just five or ten minutes, a complete picture emerged of who each of these people is and how they feel about each other. The man displayed anger and aggression about the decision and demanded that his wife change her mind. The woman appealed to her husband's feelings as a father and to the love they had for each other. As does an audience in the theatre or a film however, the author was able to see much more deeply into their personal psychologies than they could ever know or admit or intentionally share with strangers.

It was crystal clear that the man was feeling a deep sense of guilt and inadequacy about not being able to support the family solely on his own income. Because he was unaware of this or unable to admit it, he blamed her for what he feared about himself. He accused her of wishing she had married "some lawyer" with a big paycheck rather than him. He manipulated her by using her love and decency against her and making her feel that she was "betraying him." It was also clear that she feared that she wasn't good enough for him and that he thought she had changed since they had the child. Much of her energy was in the direction of "If only he would know how much she loved him, he would be able to accept this."

So, while the small story was about whether or not the woman would quit her job, the bigger story was about love and marriage and gender, and sociological pressures. **If this were fictionalized, the writer might be trying to illuminate a universal issue by plumbing the depths of a very specific incident. The actors' job, however, is to focus on the specifics.** The two people in the booth struggled to solve their problem and because of their behavior, the author (the audience) got their "story." This is exactly how realism works in the theatre. The characters (the couple) are engaged in trying to change each other, and the audience puts it all together and figures out the story. Those two people in the booth had no idea they were in a story and hadn't the first idea how things would turn out. Because they were completely in the moment, it allowed the author to see inside their souls. As it turned out, the woman broke down in tears and promised her husband that she would "give work another try." But there was no indication that this would be the outcome until the final moment, and the author almost leaned over the glass divider and implored her to keep fighting for her decision. Their little scene had completely engrossed the author, and he marveled at what a great little ten-minute play it was.

The Burden of the Script: The Trap of Playing the Story

Almost all theatrical projects begin with a script. We are drawn to a project because of the power of the story and the richness of the characters, perhaps by the historical or social backdrop. As creative artists, we want to be involved in getting great stories out there for the public. When we have a great script to work with, we know our odds of success are better, because it all begins with the script; however, the very act of addressing the demands of the script is precisely where the problems begin.

What would happen if this argument in the restaurant had been recorded and then written down in dialogue form? It would seem to be a wonderful scene because there are two distinct points of view, a very clear relationship with emotional claims on each other, and a most important sociological subject. It is also important dramatically that there is no obvious "right" solution, because each person's "win" is the other person's "loss"; that is, there is absolutely no way for both people to get what they want. (These are often called "mutually destructive motives" precisely because only one can be successfully brought to fruition.) Theatre isn't often about "win/win solutions." So, if two actors were handed a script of this encounter and told to read it for an audition or work on it as a scene, why wouldn't it be just as good as the original? What could go wrong?

When the two actors are handed the script and told they will perform this scene, they have an incredibly difficult journey in front of them. As soon

as they take hold of the printed page (the script), the trouble begins. When they read the scene for the first time without actually realizing it, they have become the first "audience." Inside their head and in their imagination they "play" the scene and see the two people sitting in the restaurant. From that first moment with the script, the actors are seeing the encounter between the man and the woman from the perspective of the "watcher." From this watcher's perspective, the people in the scene are "he" and "she," and they are engaged in a situation that the actors observe and from which they draw conclusions. **The actors see the situation from the outside and quickly make a judgment about what kind of people these two characters are, especially because they know how the story ends.** They see the "story" of the scene in their minds, and when it comes time for them to sit down and begin working on the scene, it is almost impossible for them not to reproduce the story they have played in the imaginative theatre inside their own heads.

So, the actors are not truly engaging in what literally happened between the two people in the restaurant. They have been given a script which is only a record of what was literally said between the two people. The script has no context, it does not reveal any of the emotional background information of the relationship between the two people, and because it is a literal transcription of what was said between them, it has no way of conveying the nuance and purpose of how and why the two people used that language to communicate to each other. When the script is especially good or is written by an acknowledged master, the temptation to "serve the script" can be even greater as the actors feel the need to "rise to the material." In short, the script gives the actors very little information, so when the actors read the script and play the scene in their heads, they supply what the script is missing. The actors "figure out the story" by reading the lines and making intuitive assumptions about the situation. They get the story from the script even though this might be quite different from the actual event that the author witnessed. This is the dilemma that actors face, and **the purpose of this book is to use Open Scenes to help actors avoid the trap of "playing the story"** and instead remind them that they actually do something quite different. This book is about what they do and what the audience does. When the actors do this well, the audience will do the same thing the actors did when they first performed the scene inside their heads. The audience, and not the actors, are the ones who "figure out the story."

This is the essence of what happens in realism in the theatre as well as film and television. Actors are given a script of dialogue that took place between (usually) fictional characters, and it is their job to impersonate those people truthfully so that the live or viewing audience can experience it and imagine it is happening in real time. In order to help them with the context,

the story, and the character relationships, a director is hired who works with them on the text. The director sits down with the actors for the first rehearsal, and the next series of problems begin. The director and the actors talk about the story and the characters. The director is the ultimate decision maker about how the story will be told, so he or she describes the situation from their perspective, and it is the actor's job to conform to the director's vision. Now, we have THREE people all dedicated to telling the story, and yet the premise of this book is that the actor can never tell the story. We have a problem, obviously.

What does it mean to "play the story," and why is this bad?

Playing the End of the Scene

First of all, the story is an interpretation of the situation, and if the actors are telling the story they are showing the audience what the situation means instead of just behaving as the two people did in the restaurant. If the actors know the story, they of course know how the story ends. Did the two people in the restaurant know in advance what would happen by the end of their conversation? When they sat down and ordered their food, were they psychically aware that they would have a fight and that it would end with the young woman breaking down in tears? Yet, the actors begin the scene knowing that a fight is coming and who wins and who loses. The first danger then is that the actors will allow their knowledge of how the scene ends to make sure the story "comes out right," and it will be evident from the first moment that the scene will end with the woman breaking down in tears. This is called **playing the end of the scene** and it happens when the actors think of themselves as the storytellers and do their best to "make the story come out the way it does in the script."

Playing the Character

The director then makes this worse by talking to the actors about the characters in this story. They speak of these two people from the perspective of the watcher who observed their behavior. They analyze the behavior of the two people in the restaurant and draw conclusions about what kind of people they are. Right from the beginning the actors are seeing the characters as "them" and trying to figure out what kind of people "they" are. Taking their cues from the "story," the director and the actor playing the man in the story analyze the behavior and jointly arrive at a "characterization." They might conclude that the man in the story is the kind of person who retains power and control over the woman by making her feel guilty and making her feel that the problem in their relationship is her fault. The director might say to

the actor, "look what a skillful manipulator your character is. He gets his wife to do what he wants and even gets her to apologize to him." The director and actor then have "nailed" the character and it is time to turn to the script.

The same process happens as the director turns to the actress playing the woman in the scene. "Tell me about **her**," the director might say, "what kind of woman is **she**?" (Many directors will demand that the actor speaks only in the first person: "What kind of person are you?" This is problematic in that it forces a situation wherein the character is speaking to a stranger—the director—about their most intimate feelings even though these feelings may be repressed.) Taking their cues from the story, the actress might conclude that her character is deeply insecure about the relationship with her husband and feeling ashamed and conflicted about her wanting to stay home with her child. The director and the actress might conclude that the woman in the story is the type of person who is needy and inclined to beg for her husband's love. "Look how your character lets herself be manipulated and give power to her husband because her need to be loved erodes her self-esteem." The director and actress have "figured out the character," and now they can turn to the script.

From an analytical standpoint, the actors and the director have done a good job in preparing to begin rehearsing this little play. They know the story, and they have "nailed" the characters. But what happens if the actors go ahead and do just that? What happens is that they will make the central mistake that characterizes unsuccessful acting; namely, rather than actually recreating the situation in the restaurant, they will be demonstrating their analytical assessment of it. They will, in effect, be illustrating the "Sparks Notes." ("It goes something like this.") The audience will end up watching two actors playing the story of a manipulative and insecure man getting his way against his earnest but weak-willed spouse. Of course the actual man and woman who sat in that booth had no such insight into their own psyche and were not aware that they were part of a story. They also were fully realized human beings rather than "types," and they don't deserve to have their lives reduced to a couple of adjectives. The actors however, have the psychological awareness of the characters that the actual people did not have. Because they are playing the story, the actors feel obligated to adopt those psychological characteristics, otherwise the story won't be told and the audience won't understand who these people are. This is called **playing the character,** and it results from the actor's misguided desire to be the one who tells the story.

Playing the Words or Playing the Lines

The script itself presents additional challenges to the actor. As we said earlier, the words on the page of the script have no context, no specific way for the actors to know why they used these words or for what specific purpose.

Acting and Performing 13

The tendency then is for the actors to take from the word symbols themselves the implied emotional quality and "say" the words that way. Here is some of the actual dialogue that the author heard between the two people in the restaurant that day.

MAN: Maybe you are just sorry you didn't marry somebody else.
WOMAN: How can you say that?
MAN: How can I say that? Because that is exactly what you really mean.
WOMAN: Please, No. I don't mean that. I don't want anybody else. I want YOU.
MAN: Stop bullshitting me. I don't believe that anymore.
WOMAN: Tell me to my face that you don't think that I love you.
MAN: (*a long pause*) . . . I'm going to pay the check.

The actors were not in the restaurant that day, so the script is the only thing they have to guide them, and truthfully, even if they were, they would interpret the scene through their own personal point of view just as an audience does. Other restaurant patrons that day might have "seen a different scene" than the author did because of their own individual histories with similar situations. In any case, the problem is that this encourages the actor to **play the lines**. By that, we mean that the actor decides to play the emotion that the words seem to imply:

MAN: Maybe you are just sorry you didn't marry somebody else. (**sarcastic**)
WOMAN: How can you say that? (**hurt**)
MAN: How can I say that? Because that is exactly what you really mean. (**accusatory**)
WOMAN: Please, No. I don't mean that. I don't want anybody else. I want YOU. (**pleading**)
MAN: Stop bullshitting me. I don't believe that anymore. (**attacking**)
WOMAN: Tell me to my face that you don't think that I love you. (**desperate**)
MAN: (*a long pause*) . . . I'm going to pay the check. (**cold, dismissive**)

Once the actor gets the script in his hand, it is very difficult to avoid interpreting the emotion that the lines seem to indicate and then playing the lines that way. The actor is therefore playing the script as if it were music: letting the words on the page tell them "how to say the line." The actor feels it necessary to say the first line sarcastically because that is what the script seems to "say" or indicate. The actress then feels the need to put "hurt" in her voice when she replies, "How can you say that?" Playing the script in this

way means that the actors are letting the words do all the work instead of actually acting. They are trading emotional qualities back and forth because the script "tells" them to do that. But, is that what the couple in the restaurant was doing? Were they simply displaying emotional qualities for each other? Wasn't there an urgency in their conversation and a compelling need to change the behavior of their respective spouses? Were they thinking to themselves, "oh, now my next sentence will be threatening," or "I will seem hurt and crushed with what I am about to say?"

This is, of course, ridiculous because the couple was so absorbed in the substance of their verbal engagement that they had not the slightest idea of the emotional qualities of their words. They were living their lives; they were not playing a script. But, years of working with students has taught the authors that the natural propensity of actors is to get their emotional cues from the word symbols and thus allow themselves to be played by the text.

Playing the General Sense of the Scene

Another problem that a script presents to an actor is that the scene is generally a familiar one: two spouses in conflict about money and parenting. For the actor, the temptation is to understand the scene and the conflict generally because the story is a fairly common one. The script exacerbates this because it provides only the symptoms of the fight and gives the actor only a general sense of what actually happens. Since this kind of scene is familiar to the actor, it is very easy to play the general sense of the scene. ("oh, yea, this scene goes like this.")

However, the scene witnessed by the author was VERY specific, and there is simply no way that any script of the scene could ever really convey the background details that made the scene real, incendiary, and very specific to the two people in the room. The inability of the script to provide the critical emotional details that drive the marital relationship tends to "level" the man and the woman into generic husband and wife, but both people are unique individuals, and the script doesn't tell the actor much about their lives before the moment of the confrontation. For example, what are the specific reasons he wants her to work? Is it because he wants to build a college fund for the child in question? Is it because they need a new car and or they have a debt burden? Or is it because he wants his wife to have the (specific) things he knows she wants but feels guilty because he can't give them to her himself? Maybe he hates his job and wants to start that business he's always dreamed of but can't even consider that if she gives up her job. The actor will seldom find the answers to these questions in the script. Part of the art of acting—and, we believe part of the fun, excitement, and satisfaction—is to creatively supplement the script with emotional detail that transforms a

general scene into a specific encounter. In a time when little seems to be valued more than "authenticity," it is essential that the actor find answers that truly live in them. Using Stanislavski's "Magic If" ("If I were in this situation. . .?") as opposed to thinking "what is this guy like?" seems more important than ever.

The same challenges confront the actor playing the woman. Specifically, WHY does she want to be home with her child? Is it because her mother wasn't there with her when she was a child? Or perhaps because her mother WAS there with her and she had a wonderful childhood and she wants that for her child? Is it because she hates her job and is being harassed at work but is afraid to tell her husband? Or might it be that she is powerfully attracted to her boss and wants to get away from that situation before something devastating happens? Maybe it is because she believes her husband really wants her to be home but is afraid and needs her to make the decision for him. Again, the answers to these questions are not in the script. So, "playing the script" without this creative supplement would be like singing the words of a song in another language without any idea of what it means. **It is essential to understand that this DOES NOT imply getting "the right answer" in the sense that every actor needs to "do it this way, the 'right' way" but that the individual actor must find the best way <u>for her</u> to embody the character's reality.** The audience will, of course, never know (or care) what specific set of emotional supplements the actor had added in preparing the scene. (Postshow discussions will likely reveal that various audience members interpreted things differently, filling in the backstory and motivation based on their own experience, and that is perfectly fine.) What they will see is a more exciting scene. They just won't know why.

Understanding what makes a scene specific is especially critical for actors who are auditioning for theatre, film, and television, using "sides," or short bits of scenes from new or unfamiliar material. As we will demonstrate in Chapter 4, the casting agent will often hand an actor a short scene (a *side*) and say, "take 15 minutes and see what you can do with this." The Day Player in television and commercial work faces this all the time. In many cases, the actor won't be given any more information than exists on the pages of the side. Many of these scenes will be variations on a theme that is often seen in film and television, and it is therefore tremendously important that the actor learn not to play the general sense of the scene because the casting person is looking for something "original." Playing the story by just taking cues from the script alone will rarely get the job for the actor. As soon as she recognizes that she has seen "scenes just like this a hundred times," the actor must tell herself that she must provide the unique emotional details that the script does not contain. As you work through the Open Scenes in this book, you will be required to do the very thing that

the actress must do at the moment of her audition: enrich the script with specific emotional detail.

Playing the Problem: Playing the Mood

Akin to playing the script and taking emotional cues from the lines is the natural tendency of actors to **play the problem**. As soon as the actors read the script of our restaurant scene, it is obvious that the two people in the scene are in a precarious situation. Their marriage and family are on the line, and they both are at an emotional peak. Both of them want different things, and each is angry, frustrated, hurt, and threatened. In short, they have a *problem*. Naturally, the actors see the nature of this problem when they read the script, and the lines tend to reinforce the mess in which the people are mired. In keeping with the false idea of the need to play the story, the actors are drawn into the swamp of illustrating the problem in which their character is trapped and thus "playing the problem." Since the actors are playing the story and the story contains a major problem, the actors feel that the only way the audience will understand the story is if the actors make the problem absolutely clear. This problem playing traps the actors into **demonstrating the mood or state of being of their characters,** and the man and woman in the scene are no longer trying to do anything to solve their dilemma, they are simply mired in a swamp of general emotion in an attempt to illustrate the problem as part of playing the story for the benefit of the people in the audience. Because playing the problem traps the actor in general, self-focused energy, it also means that the audience will never experience the complexity or real significance of what is actually at stake in the scene.

All these symptoms of unsuccessful acting: playing the story, playing the end of the scene, playing the lines, playing the character, playing the problem, playing mood or state of being are ALL the direct results of having a script handed to an actor. Because the script chronicles an encounter between (usually) fictional people, and because these people are not the actors, and because the words that are printed on the page have never been spoken by the actors, and because (often) the actors have never been in the situation that is dramatized, it is a very difficult task for actors to convince an audience that the words and emotions actually come from themselves. How can an actor ever hope to make the words of someone else sound like her own? How can an actor ever hope to make words printed on the pages of an acting script seem as if they came truthfully from his own emotional life? How do actors avoid the shackles placed on them once they are handed a script?

Bridging the Gap: Using Open Scenes

Most readers of this book will be familiar with the established Stanislavski-based acting methodologies in North America that have been created to address this challenge. Sanford Meisner emphasized behaving truthfully in an imaginary premise and "doing something" to the other person in a scene; Lee Strasberg taught the "substitution" methodology in which the actor temporarily becomes the character they are portraying, and Stella Adler adopted Meisner's emphasis on action but emphasized the need for a rich imagination and incorporation of personal life experience to bring the text to life. All of these brilliant teachers developed their work to help the actor transform the text from the words and emotions of "somebody else" to truthful and artistically exciting experiences for the audience. All three of them developed specific exercises that bridged the gap between beginning improvisational instruction and actual work on a play with that cursed script.

This book offers another way of bringing an actor from improvisational exercises to actual script work. Our years of teaching and directing actors have demonstrated that once an actor is handed a script, most of the improvisational work meant to teach them what good acting is, goes out the window. The script so tempts them to be the storyteller that they forget the foundational exercises learned in their first acting classes. Our purpose in using Open Scenes is to bridge the gap between improvisation and scene work in a more creative way. These ARE scenes and in fact the actor has a script in their hands from the first page of this book. But Open Scenes don't allow the actor to play the story because (by and large) there is not a specific story to be played. By working through the various levels of Open Scenes from short, content-less, single dramatic moments to complex parallels to actual scenes, the student will hopefully learn the lesson that they must never, ever, be the one who tells the story that is written in the script.

2 Open Scenes (Without Context)

Finding the Action

Finding the Action

Advice to the Players

A: There's not much to go on here.
B: Yes, these are deceptively simple.
A: And, yet...
B: Exactly. And yet, they can reveal so much.
A: And you call them "Single Action Exercises"?
B: Yes.
A: Because?
B: Because one person—in this case—enters with a clear, simple purpose; something that should be easily accomplishable.
A: To retrieve his jacket, for example.
B: Exactly. That's all he has to do, without embellishment.
A: But he encounters B—
B: Who may or may not be helpful.
A: Exactly.
B: So, A enters with a purpose and reacts to whatever they are presented.
A: Without losing sight of their single intention.
B: Simple as that?
A: Simple as that.
B: Sounds good. But why wouldn't teachers just write their own?
A: They can and probably will at some point just to keep it fresh.
B: So, why do they need this book?

DOI: 10.4324/9781003242444-3

A: Open Scenes are just the vehicle to explore the principles of acting laid out here.

Also, the Advanced Scenes are more complex. Besides, when they get to that point, the teachers probably shouldn't double as the author.

B: Or they'll become invested in the playwrighting aspect.

A: Exactly. Stay focused on the students' acting.

B: Sounds great. Can't wait.

RULES OF THE ROAD

Before we begin work on Open Scenes, it is important that some basic guidelines be established so we all approach the material in the same way.

1. **It is not permissible to alter the dialogue in any way.** You have infinite choices to make within the scripted dialogue, but you may not change the words. This is not because we think these scenes are high art but because it is the function of writers to write and actors to act. Figure it out and make it work for you precisely as it appears on the page. Bend the words to suit your meaning, but do not change the words. (Ignoring punctuation, however, is perfectly fine.)
2. The actor's goal in these exercises is not to **perform the scene *in the correct way but*** simply to find one of the myriad ways of serving the scene with internal logic, coherence, and integrity. It is up to the director to decide whether this way fits the overall vision of the production and to ask for adjustments if/as necessary. The deeper you have explored the material and the more specific you have been in your preparatory work, the easier it will be for you to take direction on the spot in real time "with the meter running."
3. **You must learn to pay attention to the twinge you feel when something doesn't make sense to you.** Develop your curiosity and discipline to wrestle with the puzzle of the script and figure it out for yourself. Sometimes this is as simple as looking up the definition or pronunciation of a word that is unfamiliar. Given this new knowledge, your imagination can take over. Who uses this word? Why would I use this particular word in this particular situation with this particular person at this particular time? You must not rely on "the kindness of strangers" to provide you with basic information anyone could find out in ten seconds on their smartphone. Yes, the director or script supervisor or dialogue coach or dramaturg can provide the information, but do you really want to be *that actor*; the one who hasn't done their basic homework? And if you haven't done the work ahead of time, what

chance do you have to make use of this new information in the heat of the moment while 50 people are standing around waiting on you to digest it and act on it? Trust is hard won and easily lost. Besides which, this is a large part of the fun of acting: giving free reign to imaginative exploration. Don't allow yourself to gloss over something that makes you uncomfortable. Better to "feel dumb" in the privacy of your own home than expose your ignorance and sloppiness on the set.

How an Open Scene Works

The first stage of this book is learning to work with an introductory Open Scene that is very simple. Despite the fact that these scenes lack complexity or story—or rather, precisely because they do—they teach critically important lessons about acting.

Here are two Open Scenes that serve as the first step in the process of reinforcing the basic principles of acting laid out in Chapter 1. These kinds of Open Scenes are sometimes called "context-less scenes" because there is no explicit information in the text that tells the actor what the scene is "about," so the scene is seemingly without context. To the untrained eye it is meaningless, nonsense . . . gibberish. Yet, these small scenes can teach some of the most important lessons about what constitutes effective acting.

Scene One: *Why Would You Do That?*

A: Why would you do that?
B: Seemed like a good idea at the time.

Scene Two: *Are You Kidding Me?*

A: Whoa!
B: What?
A: Are you kidding me?
B: Sorry.

What can we say about these little scenes? First, they dramatize a single moment instead of the multiple moments contained in a more complex scene. There is obviously no explicit story that the actor can play, and the words have no specific meaning by themselves because there is no context. Rather than a hindrance, these limitations demonstrate two incredibly important things about acting. First, the actor learns that she cannot take her cues from the lines and "play the script" as if it were a piece of music; that is, that F# is always and without exception F#. In this case, it is impossible

because there is no coherent script to "play." But the bigger lesson is that the actor can NEVER take their cues from the lines as if they were notes to play on an instrument. Instead, as we will demonstrate, it is the actor who gives specific meaning to the lines and not the reverse. The second is that the actor, not the script, creates the specific context, (the given circumstances) in which the scene takes place. As the scenes become more complex, the script offers important clues to the contextual background, but it is always the actor who makes the final decisions about the given circumstances. From the very first Open Scene, therefore, the actor learns how little specific information the script actually contains and how much work he must do to bring it to life.

Situation and Context: The Premise

What do the actors need to do to prepare to perform these scenes? The most obvious thing to do is to create a situation or set of circumstances for the scene. Where does this scene take place? Who are these people in relation to each other? This is a wonderful opportunity to apply the definition of dramatic action developed in Chapter 1. The premise or set of circumstances cannot be two people simply talking about something or describing something or joking about something. So, for example, if two actors chose a situation for *Why Would You Do That?* in which B puts a frog in his mouth, and A is appalled, it would simply be a description of the situation. Actor A would ask a question and actor B would answer it: "Why did you put the frog in your mouth? "Because I had the urge." There is no *action* in that premise because there is no conflict. Conflict is the indispensable ingredient in every successfully written scene.

Choosing a situation then requires that the two characters have contrasting/conflicting points of view and are engaged in trying to change the other person. The actor then learns that the lines give her the opportunity to "do" something to the other person. The line is a weapon used to create a response in the other person that will potentially change them. Therefore, the actor must know specifically what they want the other person to do, or say, or how they want them to change in the moment of this little scene.

Potential Scenarios for *Why Would You Do That?* And *Are You Kidding Me?*

1. A and B are going to a wedding and both think the other is badly dressed
2. A and B just kissed for the first time and are unsure why it happened
3. A and B are about to skydive and want the other one to talk them out of it
4. A and B are angry at each other and both are demanding an apology from the other

Of course, there are countless other situations that are possible, but again the important point is that the scenario involves conflict between the characters. Conflict in this case means they want to change the behavior of the other person. So, in Scenario A, both people want the other person to put on different clothing because they think it is inappropriate for the wedding. Using this premise for *Why Would You Do That?* means that the actors must use their line to get the other person to realize they are badly dressed and should change clothing. Character A's line, "Why would you do that?" needs to contain the energy that makes character B feel foolish. It is the energy that accomplishes that and not the word symbols. "Why would you do that?" needs to make character B feel ashamed at his clothing. The same is true for character B. It is character A who is badly dressed and the line, "seemed like a good idea at the time," needs to do the very same thing; make character A run back in the house and change clothes.

Learning to Play Action

This energy that bends the word symbols to serve the purposes of the character is called *action* because it does something to change the other person. The lines are a response to the situation and not the reverse. The question the actor asks is not, "what does this line mean?" but rather "what response do I want in the other person and how will I get it with these words?" Given this particular scenario, the line, "seemed like a good idea to me," contains the energy that might be paraphrased as "because I understand how ADULTS dress for a wedding." A good way to practice using the energy to bend the line to serve the actor's purpose is to use paraphrase. Try doing this:

A: **We are going to a wedding not a barbeque, so change your clothes, now.** Use this paraphrase and say the line. Then use the same energy, but say the line, **"Why would you do that?"** Notice that it is not the word symbols but the energy, the action that does the work.

B: **I understand how ADULTS dress for a wedding. Now, you try it.** Use this paraphrase and say this line. Then, use the same energy but say the line, **"seemed like a good idea at the time."**

An important lesson about acting is made clear by this exercise. The actor needs to make certain decisions about the situation and determine how they want to change the situation. The change they want is their *objective* or *need* and this desired change informs them what they want to do with their lines. So, THEY determine what the lines "mean" by what they want the lines to do to change the other person. In this case, the actor has determined that the situation is that the other person has dressed badly for the wedding. The

objective is to get the other person to change into something more appropriate. Thus, the actor can't just look at the line and simply ask a question, "Why would you do that?" She has to get her partner to change clothes. So, she bends the lines to produce that result. "Why would you do that?" is transformed from a general question to a powerful action. The actor makes the lines mean something; they are meaningless until he does that.

In doing this exercise, avoid the temptation of featuring your cleverness. Remember that it is not essential that the audience understand that you are headed for a wedding. We don't care about the "given circumstances," and it is not your job to make sure that we "get it." We are interested in the dynamics between the two characters. This isn't Charades. Also, while it is entirely possible that B could say "It seemed like a good idea at the time" to indicate that she now understands what she didn't understand before and acquiesces to A's desire, that choice would serve as the end of the world's shortest play. A wanted something, and B gave it to her. The End. ("Let's go to the movies." "Okay." The End.) A scene is like a tug-of-war, and only by pulling back on your end of the rope you keep the scene alive.

Rehearsing the Scene

Let's use Scenario Two for *Are You Kidding Me?* Remember that in choosing a context for the little scene, the actors cannot simply be talking about the kiss. There is never any scene in a play where two characters are just discussing something. It may look that way to the audience, but in fact a scene is always constructed with two people holding contrasting points of view about the situation. Even in a quiet, domestic scene where it seems two people are in complete agreement, there is an underlying element of action; perhaps reassuring one's partner of a shared allegiance to a particular point of view. This often occurs just before something dramatic happens to upset the ordered lives the characters have been enjoying. So, the characters are trying to resolve something, or win the argument, or get an apology, or get the other person to laugh or cry or slap them or KISS them. A scene must always have conflict (two people trying to change each other). If they are trying to change each other, then the audience watching them will get the story. In terms of scene work, even agreeing with someone is a means to getting something from them.

In Scenario Two, the actors must decide what they are trying to get the other person to do, or say. Again, don't try to "figure out" what the words "mean." They don't mean anything until they are used to get a response from the other person. Just because the word "Whoa!" is the first line, it is NOT an indication that something has to be stopped. This exercise is designed to teach the actor to use the word as an action and not "play" what

the word suggests. For the sake of this exercise, let's imagine that both A and B love the other person, but they aren't sure their partner feels the same way. They both want the other to state their love clearly. So, the objective is the same for both characters, it is their point of view on the situation that makes the conflict.

In this scenario, the scene could begin just after the two kiss each other. What response does A want from B with the line, "Whoa!" Remember A's goal is to get B to admit his/her love. The actor needs to make the word symbol, "Whoa!" do something that could make B admit his/her love. The same is true for B. How can the word "What?" get B to admit his/her love for B? If actor B plays the line and simply asks a question, "What?", he/she will have no chance of getting A to express their love. The actor needs to bend the word "What?" to get the response from A that he/she wants. As we did with the first scene, let's try paraphrasing to make the point again that it is the energy and not the word symbol that does the changing. Say the paraphrase and then use the same energy but say the word the script has given you:

A: **Only someone in love kisses like that**. Say the paraphrase and then use that same energy but say the word**, "Whoa!"**
B: **You love me, just TELL me**. Now, say the paraphrase and then use the same energy but say the word, **"What?"**
A: **Your chance is now, SAY IT!!** Use the energy of that paraphrase but use the words, **"Are you kidding me?"**
B: **I can see the truth in your eyes!!** Use that energy of the paraphrase but say the word symbol**, "Sorry."**

Now, do the scene as written. Do you notice what happens? The lines "mean" what the actor has MADE them mean in order to get the response he/she wants from their partner. The couple in that restaurant in Chapter 1 was not talking word symbols back and forth, they were communicating powerfully using words. As our Open Scenes become more complicated, one thing will not change. The actor can never look to the script to find out what the words "mean." In every Open Scene and indeed in every scene from a play, the actor creates the context (the given circumstances) and objective and then bends the lines to serve his/her need to change the other person. In that restaurant scene, the man actually said the words, "Are you kidding me?" In the context of that argument, he used those words to try to shame his wife into seeing how much her behavior had hurt him. At the moment he was trying to get her to see that she was guilty of the very thing of which she was accusing him. So, the energy of the line was "Well THAT is the pot calling the kettle black, isn't it?" Therefore, the word symbol

he used communicated that energy. It sounded like this: "Are YOU kidding ME??" How could any script ever convey that context to an actor? Of course, the answer is that no script can ever do that. But each actor who picks up the script of the "Restaurant Scene," is obligated to create a context and objective that will allow him/her to make the words specific and purposeful. Beginning with these first Open Scenes, this book will emphasize over and again this vital acting lesson: *Don't play the lines and don't play the story.*

Changing the Premise: Changing the Action

Closing these first Open Scenes, use Scenario 4 for *Are You Kidding Me?* Scenario 4 is a good one to use because scenes in which two characters are angry at each other are very common in drama. They are perilous for the actor and very instructive for our purposes here. Give an actor a script with angry language in which two people are engaged in a fight or an argument of some kind, and the temptation to play the script is overwhelming. But as we said in Chapter 1, the difference between a scene in life and a scene in a play is that in the drama something happens. There are no scenes in any play in which characters are just fighting or just objecting to each other or just venting. In life, two people might be fighting and venting and screaming at each other with absolutely no expectation of any constructive outcome, but the playwright chooses the time in which something is resolved or finished or completely broken apart and so the scene is not about the fight, the scene is about the characters trying to change each other. In effect, they are not trying to fight, they are trying NOT to fight, they are wanting to end the fight or fix the problem. If the actors are trying to resolve the fight and change the other person, it will look like a GREAT fight to the audience.

Here is your chance to prove this principle of acting. Take Scenario B and apply it to *Are You Kidding Me?* Let's imagine A is waiting for B in the apartment they share and is angry because B didn't show up for the rehearsal of their scene for class. B is angry because A scheduled the rehearsal at the last minute without even asking him and he had already planned the evening. Okay, so they are angry at each other. The authors of this book have seen umpteen examples of actors who "play the fight" and basically just stand there and scream at each other with no possibility of changing the other person. Once again, we emphasize those words: *changing the other person.* If an actor doesn't know exactly what specific behavioral change she wants to effect in the other person, she will play the story (the fight) rather than the action (making something happen to the other person in the scene).

Both characters want an apology from the other, and this is both the objective and the action of the scene. As B enters the apartment, A has the first

line. The question for the actor is what energy will he use to make the word symbols, "whoa!" to get an apology from his roommate? He must expect that when he says, "Whoa!" that B will get the message and apologize to him. What is the actor playing B going to do with the word symbol "What?" to turn on the lightbulb in A's head that causes him to apologize? The point is that both of them don't want to fight, they WANT AN APOLOGY!! Playing anger and screaming at the other person is NOT likely to get an apology. So, instead of playing their anger, they use it to be more effective and articulate in getting the other person to apologize.

Returning once again to the paraphrase exercise to capture the energy that will bend the word to serve it, try this:

A: **Where are you going? You got something to say to me?** Play that energy and then use the same energy but say your line, "Whoa!!"
B: **You think you are the only one with a life?** Play that energy and then use the same energy but say your line, **"What?"**
A: **How do you think I felt when you stood me up?** Now, make the words, **"are you kidding me?"** and get the same response from B.
B: **Here, since you apparently can't say it, let me say the word FOR you, SORRY!!** Ok, say that paraphrase and use the same energy to say your line, **"Sorry."**

Getting an apology is too important for both characters to lose themselves in anger. As you encounter Open Scenes in this book in which two people are angry at each other, or perform scenes from plays in which there is a fight, remember this important acting lesson: the angrier your character is, the more articulate they must become. Anger is never something you can play, rather it is the fuel that powers what you DO play; namely, changing energy. Anger is the story not the action. It takes constant practice not to fall into the anger trap.

Take these two Open Scenes and invent your own scenarios. Choose the scenario and make the words serve the scenario instead of trying to think of a situation that the words suggest. Remember always that the scenario must involve some conflict between the two characters. By conflict we don't necessarily mean anger and contention. Conflict results from two people trying to change each other, so make sure your scenario gives each character something important they want to change in the behavior of the other.

Conclusion: With these first Open Scenes, there was virtually nothing in the scripted dialogue that an actor could use to discover the "intended" premise or given circumstances. As the Open Scenes become more complex, it will always be true that the actor can never play the text. But increasingly,

the actor will search through the text to find important clues for the given circumstances just as we had to invent in working with these first Open Scenes. While it is always worthwhile to examine alternative meanings and choices, there is no reason to obstinately overlook the obvious just on principle. (There's no extra credit for being different.) Just don't treat the obvious in a general manner.

To return to our restaurant scene from Chapter 1, the actors would search the text to find out that the couple was married, that there was a central issue of contention between them and that it takes place in a restaurant. The dialogue will also provide other hints about the relationship and the situation. As we will see in subsequent chapters, there is a critical difference between exploring the text and playing the text. Maybe this particular couple has a baby but is not married. Perhaps the baby is adopted. Perhaps they never really wanted a baby. Or one of them didn't. Perhaps they wanted nothing more than a child and had to go through a great deal to conceive. If any of this really matters, it's up to the writer to provide the audience with that information. It's the actor's job to simply play the dramatic action. One of the reasons we rehearse is to test the various choices available to us. The best choice will be the one that activates you the most.

Exercises

1. Go to the Index of **Basic Scenes** at the back of the book and practice activating your imagination by creating scenarios for the given words and transforming that into dramatic action. Try out different scenarios on your feet to begin to understand what stimulates you the most.
2. Write your own context-less Open Scene and create several scenarios. Remember to create the situation first and make the lines serve your objective in the scene. [Please heed our caution not to become invested as writer.]
3. Use the paraphrase method to practice the ability to create the energy that powers the word to change the other person. For example, get your partner to take off her backpack and put it on the ground. First use the words, **"That is MY backpack, take it off."** Feel the energy that you are using to get her to do that. Now, use the same energy to get her to do the same thing, but use the word symbols, **"That is the point!!"** Notice that it is not the word symbols that get her to do that, it is the energy behind the word symbols. Try doing this exercise with many other combinations of paraphrase and actual line.

* * * * *

A THOUGHT ABOUT ANGER. In the wake of a spouse abuse situation, a counselor asked what happened, and the man said that he was holding a frying pan, set it down, and hit his wife because he was "out of control." The counselor asked why he put the frying pan down and was told, "Otherwise I would have killed her." At that, the counselor said, "It doesn't sound to me like you were out of control. It sounds to me like you made a choice and gave yourself permission to hit her." We mention this because even when "enraged," people are not conscious of their state of being. While in the midst of rage people are not saying to themselves, "I am really angry right now." Instead, people make choices and then often later justify their desire to act in certain ways. The only way an audience can see that your character is consumed with rage is if you engage in specific, purposeful behaviors that are fueled by your character's anger instead of general displays of anger solely to demonstrate to an audience that your character is out of control.

3 Investigating the Script
Give Me a Place to Stand On, and I Will Move the Earth

In the last chapter, we looked at Open Scenes that required no attention from the actor toward the language because the scenes were virtual without context. This was for the purpose of establishing dramatic action and not speaking the word symbols as the basis for successful acting.

But, of course, scenes from plays and film scripts do require that the actor understands how to glean from the text the things necessary to perform them. After all, the actor is not operating in a void. We're all working off the pages as written, so it's important that the actor knows what to look for and how to read a script as an actor must. Look at this Open Scene, titled, *A Lot to Ask*.

A Lot to Ask

A: I know it's a lot to ask. I just—
B: It's all right.
A: I appreciate that.
B: I'm happy you asked. I think it's—
A: Really? That's great.
B: Sure.
A: Surprising, but—
B: I guess I meant more flattered than happy.
A: Oh, okay.
B: I mean, it's a lot to ask.
A: I know. And I wouldn't ask if it wasn't important.
B: I appreciate that.
A: Or if there was anyone else to ask.
B: Sure.
A: So?
B: What?
A: Well. . .

DOI: 10.4324/9781003242444-4

B: Oh. You need an answer right now?
A: Well, time is critical. Of the essence, as they—
B: Sure. I understand.
A: Sorry. I'm sorry. I don't mean to push—
B: No—
A: Or pressure you—
B: Stop.
A: Sorry.
B: I just need a little time.
A: I understand.
B: It's not "no," I just need to—
A: When?
B: Pardon me?
A: Do you know when you can give me an answer?
B: No, I don't. And this isn't helping.
A: Sorry.
B: Just take a breath.
A: Okay. I'll leave you alone.
B: Okay.
A: You've got my number, right?
B: I do.
A: Okay.
B: Okay.

What to Look for in the Script: First the Story

What does an actor have to "get" from the words written on the page of the script? When presented with this Open Scene, the actor needs to ask himself the same questions he would if examining a scene from a play or film, except that there is nothing that precedes or follows this moment. The actor first reads the scene to get the "story" of what happens in the scene. In *A Lot to Ask* there is a dialogue between two people, and person A is asking something of person B. As the story goes, it seems that B finds it difficult to give A what they want. Character A wants an answer right away and Character B feels pressured and insists on more time. The scene ends with A relenting and offering a phone number that B could call with an answer. This is what literally happens in the Open Scene, and getting this story from the script is the first step of the actor being able to perform it. A basic principle of good acting (and writing) is that whatever it is that A wants, only B can provide it. If, for example, A was looking for a bank loan and this was just the first loan officer he was talking with, there would be no relationship of interest for us, and there would be no urgency because another loan officer would

A Word About Researching the Text

It is important to emphasize that "not playing the text" is completely different from examining the text for essential information about the scene. The premise or given circumstances of an open scene is usually pretty simple and straightforward, but in a play or film script the given circumstances (backstory) are very often complicated, frequently requiring extensive research by the actor. Truthful social behavior in 21st Century America is quite different than 20th Century South Africa, 19th Century Russia, Elizabethan England, or Ancient Greece, and there are important classes and social differences among people living in each of those eras. Understanding the conflict in a scene is impossible without fully comprehending the social, political, and interpersonal premise in which the scene is located. Creating a point of view about the other character is predicated on a full appreciation of locating the relationship in the time and place set by the writer. When the phrase "mining the richness of the script" is quoted, it means that the actor is using the text for clues that allow her to dig deeply into the background of the characters and situation in which they find themselves. The purpose of this research, the goal of "mining the script," is to develop the most informed, compelling, and specific point of view possible.

do just fine. Also, it is easy to discern a sense of urgency from some of the word symbols even though we don't know what motivates that urgency. A clearly is pushing for an answer "now." We don't know why it is urgent, and—again—if the facts of the case matter it is up to the writer to lay them out. The facts are absolutely NOT important to the audience in this exercise; only the dramatic action is. How does this urgency play out? Certainly, it is the director's job to determine the pace of a scene, but an actor reading this should be able to determine on his own that the tempo picks up enough at one point sufficiently for B to feel compelled to say, "Stop. I just need a little time." The writer has also provided the dashes at the end of lines, indicating interruptions and rapid rather than pensive responses. That increase of tempo, however, is a byproduct of his urgency, not a playable action.

Next: The Dramatic Action

The second step is for the actor to look for the **dramatic action**, the **conflict** in the scene. This is critical for actors, especially in film and television work where the dramatic action might be very subtle and not apparent in

the dialogue. Actors must become bloodhounds for finding the conflict in the scene. In this scene, the conflict is pretty clear in the dialogue in that character A needs character B to do something and character B does not want to do it (at least is unwilling to do at this time). So, the dramatic action is the push and pull between someone who wants something and someone who will not do it because they want something else.

Next: The Premise or Given Circumstances

The next step would be to examine the premise or **given circumstances** of the scene to provide the context for this encounter. Since this is an Open Scene, these given circumstances can be invented by the two actors. This means that this scene can be used over and over by simply changing the underlying premise and circumstances. But, for the purpose of this book, let's adopt this premise. A and B are in a love relationship, but neither one is exactly sure how deeply the other feels. Character A is about to leave for an overseas military deployment and has just asked Character B to marry him. She is surprised and flattered but cannot give him an answer. With this premise, we know that they have a serious relationship and that the deployment has created a sense of urgency that has created this moment.

Next: Point of View

If this were a scene from a longer play or film, we would be able to talk about their relationship and the way they felt about each other by examining how they interacted in other scenes from the script. Again, in an Open Scene, we get to invent this **point of view** that tells us the unspoken details of what they think of each other. What specifically do they think and feel about each other? What unspoken (in the script) history between the two of them provides us with insight into why he is asking and why she cannot answer him? This deeply felt point of view about each other is not usually in either the play or filmscript. It is something upon which the actor speculates based on clues from the script. Indeed, the crafting of a point of view (POV) is the real "art" of acting because it is this POV that makes the character who he or she is, and it is a character's history that has created this POV, often imprinted by specific events or influences.

Given the premise we chose, let's create the following points of view for each character. Remember, this is exactly what the actors must do with any script. But, if the actor can do it with an Open Scene, just imagine how much more fun it will be when she has the entire script of a play or film as her material.

Character A: He is madly in love with B. He is sure that she feels the same way and he has told her exactly how deeply he feels. For some reason,

she has tended to back off when he gets serious even though she too has expressed how deeply she feels for him. He has decided that she starts to back off because she has doubts about his love for her and perhaps doesn't believe he is really serious. He believes that she needs him to prove to her how passionately he feels and this is his opportunity. He is about to leave for his deployment and she needs his strength and encouragement to say, "yes."

Character B: She is also deeply in love with A, but she is not sure he feels the same way. She sees him as often impulsive and inconsistent, and she is afraid that he doesn't really understand what a mature relationship is. She wants him to grow up and be the man she knows he can be because he has everything she wants in a partner. She believes that he needs to prove to her that he is ready for a lifetime commitment. "I'm sorry. I can see that I'm pushing this on you. Think about this. If this is something that is in your heart, I will always be there when you call me."

So, the two sides of the encounter are clearly set. He wants her to say yes and she wants him to say he is sorry and promise to set her free to decide herself. With the need and point of view determined, the actors are ready to approach the script. The job of each actor is to **make the words serve their objective** in the scene. It is critical that the actors always play **positive energy** in the scene, even if the word symbols suggest something negative. By positive energy, we mean effective and consistent with the need. So, for example, when character B says, "No, I don't. And this isn't helping," how can the actress play positive energy? Remembering that her objective is to get A to say he is sorry and let her consider this on her own schedule, what response does she want from A with this line? Certainly, it is not to snap at him and make him defensive or angry. That will not help her get him to say he is sorry. If his energy toward her is not "helping," what energy WOULD she find helpful? Thus, her action on this line could be to get him to say, "Ok, what would be helpful?" If he said that, she might actually say yes because he HEARD her concerns, which demonstrated the unselfishness and maturity that she is seeking.

RAISING THE STAKES: Actors have often heard the director ask them to "raise the stakes." But what does this mean and how is an actor supposed to do that? The director is asking for more dynamic tension in the scene and more urgency from you. When the director asks the actor to "raise the stakes," there is nothing the actor can do to herself to accomplish that. She can't go off stage and work herself into an emotional froth and come back on stage with the "stakes raised." Instead, she has to change something in the other person that will cause her to behave in a different way. The only way the audience can sense that the stakes are raised is through specific behavior of the characters. "Raising the stakes means making a point of view adjustment about the other character(s) that intensifies the situation

and the way you feel about the other person in the scene and then making your need more specific and urgent to reflect the increased intensity of the situation. So, for example, if you are playing a scene where you need money from the other person and the director feels that the scene is flat and asks you to "raise the stakes," how might you do that? The answer is to magnify something in the other person that makes you feel more potently about them. How would the stakes be raised if you imagined that:

1. He absolutely has the money and can easily afford giving it to you.
2. He owes you the money and is delinquent in paying you back.
3. He came by the money fortuitously; that is, he didn't earn it. Perhaps his grandfather set up a trust fund for him.
4. He came by the money illegally.
5. When you were roommates, you kept him afloat, sharing generously the little you had and never asked for anything in return.
6. He thinks you are a "con artist" and only want the money to feed your habit.

The point is that "raising the stakes" means that the director is saying that you need to behave differently toward the other person. If you change something in them, you will behave differently. The "stakes" are in the other person, not you.

> NOTE: As mentioned in the Introduction, one of the great advantages of Open Scenes in a classroom situation is the ability to engage each student in exploring the possibilities of a common scene. For example, while we used gender pronouns in discussing the proposed premise earlier, in contemporary society the same premise could apply to any two actors regardless of gender. It would, in fact, be tremendously revealing to explore how the various points of view would or could shift if A was played by a woman and B by a man or both by men or both by women or nonbinary people. Issues of race or ethnicity might but would not necessarily affect the given circumstances. Notwithstanding considerations of actually changing the premise, any of these adjustments might illuminate what it means for the actor to find the best way to activate themselves in the playing of the scene.

Exercise

Practice the scene with the points of view an objective laid out earlier. How successful can you be at bending all of your lines to serve what you are trying to get the other person to do? This is exactly what you will do in a scene.

Remember, the words on the page are not more specific than they are in this Open Scene. You give them their specific meaning when you use them as opportunities to get the response you want from the other person.

Create other premises for this Open Scene. Follow the same formula:

1. Conflict (dramatic action)
2. Given circumstances of the premise
3. Point of view
4. Need (objective)
5. Activating the script (bending the words to serve your objective)

4 Open Scenes Applied to Commercial Copy
Booking the Spot

In this chapter, we move to applying the lessons learned from working on open scenes to our first look at actual scripted material. We will begin with commercial copy, then in Chapter 5, we will look at scripted scenes from film and television, and then, finally in Chapter 6 the book culminates with applying open scenes to the rehearsal and performance of theatrical realism.

Let us start then with a very simple but important activity for an actor; namely, working with audition pieces for television commercials.

The Audition

A young actor was recently given the opportunity to audition for a television commercial that had a great deal of visual action, but only one line:

Are you really going to eat that?

The advertisement was about a product that was being compared to its inferior competitors, and the purpose of the actor's line was to express some form of negative reaction to eating the competitor's product. At the audition, the director of the commercial shot gave the actors this line and said, "Give me five or six different takes on it." Five or six *takes* on it; now what exactly does that mean? The director meant that he wanted five or six different "readings" of the line and he would hire the actor who most creatively gave him those readings. What he wanted was six different **characters** so that he could pick the one he liked the best.

Creating the Premise and the Point of View

So, how does one create a character with one line? The understandable tendency of most actors would be just to say the line in several different ways. But, **the actor familiar with open scenes has a distinct advantage** in this

DOI: 10.4324/9781003242444-5

situation because she has learned not to let the line itself suggest a way that she should "say" it. Just as is the case with an open scene, the actor instead invents six different imaginary premises and uses the line "Are you really going to eat that?" to address or fix the problem that she has invented. To do that, she "brings" five different (invisible) acting partners who complete the dramatic action she performs.

So, instead of saying the line six different ways, the actor experienced with open scenes brings along six different people (in her imagination) to the audition. The actor has a very strong point of view about each of these characters and she creates a premise involving them for which the line in the commercial is necessary. In other words, the actor never changes, she is always herself, but as each new "acting partner" and new premise arises, she feels differently about it, and what she does with the word symbols, "Are you really going to eat that?" has to change to address each new person and situation. As we learned before, **the situation is addressed by the words, the words do not determine anything themselves**.

Situation 1: The piggish little brother of the actress is the first person to sit in front of her. He has filled a bowl piled with the most disgusting-looking food in the history of the world. It is making her nauseated and is ruining her dinner. She needs to get him to admit this food is disgusting and to throw it in the trash. "Are you really going to eat that?" becomes her weapon to force him to get rid of the food. A paraphrase might be, "throw that away before I vomit on your shoes." With one line she gives us a glimpse of a character and shows the director her first "look." But, the director wanted multiple characters and multiple looks. So, what now?

Situation 2: The next person the actress has brought to the audition is her older brother who loves his image as a "tough guy." He has been especially obnoxious in his macho boasting today, and the actress is annoyed with him. She finds a sandwich that has been in his car for a week and dares him to prove to her how tough he really is by eating the sandwich. The line "Are you really going to eat that?" becomes her weapon to test him. A paraphrase might be, "Okay, I'll admit that you are that tough if you prove it by eating that sandwich." With one line the actress has given us a glimpse of a different character and showed the director his second "look."

Situation 3: The next character the actress has brought to the audition is her fiancé. It is his birthday, and she has invited him to her house and told him she would make a romantic dinner for him. When he enters her apartment, the candles are lit, the wine poured, and two places have been set at the table with food on them. He sits down at the table thinking she is perhaps in the kitchen. Instead, she appears from her bedroom dressed in the most beautiful and sexy clothing she owns and sits across from him. Her line "Are you really going to eat that?" is her weapon to get him more interested

in romance than eating. A paraphrase might be "so, what are you REALLY hungry for, Tiger?" With this one line, the actress has given us a glimpse of a much different character and showed the director his third "look."

Situation 4: The next character the actress has brought to the audition is her dominating and controlling father. The relationship is one in which, from the actress's point of view, her father berates her about her life choices and especially about her weight and her inability to marry and produce grandchildren. They meet for lunch, and her father starts in with the same lecture about diet and exercise and how that will help her get a life partner. Finally, the actress has had enough, and she uses the line "Are you really going to eat that?" as a weapon to get her father off her back. A paraphrase might be, "If you don't stop RIGHT NOW, I'm walking out of this restaurant!!" With this one line, the actress has given us a glimpse of yet another character and a much different "look" to the director of the commercial.

Situation 5: The last character the actress has brought with her to the audition is her roommate. She loves her roommate as a friend, and yet this woman also drives her absolutely nuts. One of the things she does that makes the actress insane is that she tortures waitstaff in a restaurant with numerous, detailed questions about the food she is considering ordering and then asks various things to be eliminated when the kitchen makes the food. The two meet for dinner, and her roommate is especially obnoxious and embarrassing as she asks endless questions and requests substitutions. Reaching her limit, the actress says "Are you REALLY going to eat that?" as a weapon to get her to stop torturing the waitress. A paraphrase might be "Are you ordering food or performing a lobotomy on this poor woman, STOP IT!!" With this one line, the actress has given the director a glimpse of a fifth character and a much different "look."

All these variations are, of course, merely examples of what any individual actor might create. As always, there are infinite possibilities, the only restriction being one's imagination. The point is to access your imaginative muscles and find ways to stimulate your expressive power. Always remember that your expressive power is not something you can make happen directly. When your imagination is fully engaged it works to make the other person as vivid as possible. The more vivid and formidable the other person is, the more powerful and impassioned you will need to be to engage them. The audience watches your behavior toward the other person and says, "Wow, that actor is really expressive."

Playing the Action

Notice that the skills used in making open scenes work are important to this successful audition. **The lines are not word symbols that express the reaction of the actress to something, rather they are tools to** *make*

something happen to the other person. The actress uses the words to fix the situation by getting a specific response from the other person. **Also note that the actress is always herself.** She is not a *character*. It is the **other person** who is the character. From the actresses' point of view, she is *normal*, her authentic self, but her little brother is a gross pig, her older brother is an obnoxious blowhard, her fiancé is clueless and needs his battery charged, her father is a relentless control freak, and her roommate is a one-woman, torture chamber. And, not for nothing, but the actress gets to cast the other role from the entire world. Perhaps it IS her actual little brother. But, perhaps her father is Liam Neeson. Perhaps her fiancé is Chris Pratt. Maybe her roommate is Natasia Demetriou. What would it take to step up and act opposite THEM? The audience might say, "Wow, she is so expressive!!' Your response might be "No, I'm just my normal self but I am dealing with CHRIS PRATT here!!"

Responding to the Director

Meanwhile, the director watching her sees five different characters in her. He sees a mean older sister, a mischievous younger sister, a sexually powerful woman, a rebellious, snotty daughter, and an impatient, intolerant roommate. This is what we mean when we say that the audience, not the actor, is the one who determines character. Working with open scenes is the perfect introduction to this and prepares the actor for creating character in scripted scene work.

Changing the Premise and Point of View

Let's imagine that the director was most attracted to the mean older sister character and asked you to work on that. "I like that take, "he says, "but, can you make her meaner and more disgusted with the food?" How do you respond to this request for making the character different? The director, speaking from the perspective of the observer, wants to see an older sister who is both really mean and completely grossed out. The actress knows that this cannot be accomplished by somehow making her voice "meaner" or saying the words with more anger. In fact, the actress remains exactly the same but she makes important changes in the behavior of the other character. In this scenario, her younger brother is determined to make her vomit and eats part of the disgusting food and then lets it drool out of his mouth onto the table in the direction of the actress. What is the most rational thing to do? The actress might rise to her feet to prevent the partially masticated food from getting on her clothing and use the word symbols "Are you really going to eat that?" to get her brother to close his mouth and stop this

ridiculous behavior. The actress hasn't changed anything about herself. She is still "normal" but her brother has become viler, and much more disgusting, and therefore she needs three times more energy to prevent him from slobbering all over her. To the director, it looks as if the actress has changed her character as he wanted, and he notices that she can follow directions.

The same process would be involved if the director had chosen the look with the fiancé. "Oh, I like that reading," he says, "but, can you make it seductive, but a little silly and over the top?" In other words, the director wants the actress to spoof a sexual encounter. The line is still "Are you really going to eat that?" so the words are not going to help the actress give the director what he wants. Instead, the situation and the point of view of the actress need to change. **Most important in creating character is the relationships, not the language**. In this case, the relationship needs to change, and the fiancé has to change so that the behavior of the actress will change and give the director what he wants. The director said he wants an "over the top" sexual spoof with the line. Let's change the situation. This time the fiancé has been depressed and obsessed with the difficulties of his new job, and the actress wants him to break him out of it. So, as he sits down to eat, she appears with the silliest combination of clothing she can find, plants one of her stiletto heels right on his chair, and tries to get a huge laugh from her fiancé. Since he is feeling depressed and overwhelmed, he needs a BIG, silly energy to pull a laugh out of him. It is this energy (and not the line) that makes that happen with the fiancé and gives the director who is watching this, the "look" that he wants.

An important technique of acting called "emotional packing" is a key element in the ability of the actor to change the situation and the relationship. Packing allows the actress to create her own trigger warnings that shape the way she responds to the behavior of the other person. Emotional packing is a means by which an actress creates a "backstory" about her character's relationship with the other person. "Oh, he's drooling again," may be a reasonable response when one wants to maintain a cool persona or the person's drooling doesn't really bother her character. But, since plays are not written about the day nothing happened, it isn't very likely that her character is neutral about the drooling. What if the backstory, "the packing" about the little brother is that he drools and makes disgusting noises purposely to mock the way the character talks to her boyfriend and that he revels in doing it in front of the young man. Someone who knew nothing about the relationship between brother and sister might accuse her of "overreacting," but then she would simply say, "You have NO IDEA that he is doing this on purpose to humiliate me." That is how emotional packing works. The audience has no idea about the backstory, they simply watch the character behave and say, "She has a REALLY bad temper."

The Fifteen-Second Spot Audition

Imagine you were asked to audition for this fifteen-second spot for *Bigger Burger*. The director is going to choose the actor who "brings something special" to the spot. In other words, the actor who can bring the most character to the spot will get the job. Open scenes are perfect preparation for this kind of work because, like an open scene, just saying the words will not do it and there is no story from which to draw. So, the actor needs to do just what he does with an open scene. **Create a premise and a conflict and a relationship and use the words to address the premise.** Here is the script you are handed:

> *You are watching a fifteen second ad for Bigger Burger which unfortunately isn't enough time to explain all the fresh ingredients in their new menu item, but, I've got an idea: "Okay, Google, what is the Bigger Burger?"*

Play It Just Like an Open Scene

That is the script. How are you going to make a character out of THAT? The script is purely factual with a cute question at the end. There is no context and no other characters and no visuals except the burger. The answer is to approach it just as you would an open scene. Let's imagine this as the premise: The actor goes to the audition and instead of a script, the director hands him a prop sandwich and asks him to improvise something about the Bigger Burger for 15 seconds. This REALLY annoys the actor because it is just plain stupid and how in the world is somebody going to talk about a Bigger Burger for 15 seconds? Thinking the audition is ridiculous and probably accepting that he will never get the job, the actor decides he can use his feelings about the audition to make something happen to the director. He speaks right at the director as if to say, "You want to create a gimmick audition, Okay, I'll GIVE you a gimmick audition. ... use GOOGLE!!" You are trying to get the director to say, "yea, you are right, this audition format is really stupid, let's try something else." Of course, when you have that as your objective what the director sees is a character who is a wise-ass with a brilliant idea.

Try working with this commercial spot yourself. Use the following premises and see how it changes the "character" you are presenting. Remember you play point of view and action. The character is the label the audience provides after watching the behavior that they see you produce.

1. Your friend is auditioning for this spot and is completely without a clue how to read it. He knows that you know exactly what the ad agency wants. Thirty seconds before he goes into the audition, he desperately calls you on his cellphone. Carefully coach him by doing the speech so

that he understands what is the most important part of it. What character would the director see?
2. You are a drill sergeant in the army who is disgusted with the ineptitude of your platoon. They are SO THICK you have to spoon-feed them everything. They don't know how to make their beds, or march in line, or clean their rifle, or even EAT A HAMBURGER without you showing them. So, as if you are talking to five-year-old children, you make it VERY CLEAR what a BIGGER BURGER is. What character would the director see this time?
3. Approach this like an open scene and come up with two or three premises of your own. What character emerges?

The Thirty-Second Spot

This time you have been given audition copy for a thirty-second commercial. The technology company *BOOKIE* has asked for a male read, and the *Mom's Yogurt* company has asked for a female read. There are 20 or 30 other men and women waiting to audition as you are handed the copy. Obviously, the actor who gives the most interesting read and produces the most compelling character will get the gig. Again, what open scenes has taught you is that you cannot look to the words to do your work rather, and since there is no story or context to this commercial you need to imagine a situation where you **use the words to solve a problem or get a specific response**. Creating a character requires a relationship in which you are trying to change something about the person to whom you are speaking. This is the BOOKIE spot.

> *That there on the phone is BOOKIE, the sports betting App, where every time you place a bet, your odds get BOOKIED. What does getting BOOKIED feel like? It feels like catching a glass before it hits the ground and the catch is so amazing you never stop holding it. And you keep holding it... forever ... and ever.... And you just never stop holding it. And everyone is like, "why is he holding that glass?" Until they find out that you caught it when you opened the cupboard. And once they understood that they think, "Oh, I get it." That's the best feeling available to a human being. And that, more or less, is BOOKIE.*

The Same Formula: Premise, Point of View, Action

Just like an open scene with some content, this script has some literal content in that it is advertising a sports betting application for cellular phones. It is also written to be humorous because it asks a question about what the App is like and then engages in a story of some sort that has nothing to do with the technology of an App on a cell phone. We know from our work with

open scenes that it is up to us to provide a situation and a relationship that require the words to engage them in some way. Remember, you don't look to the words to try to figure out the premise. Rather, you choose the premise and make the words address the situation that you invented.

Exercise

So, let's create some premises and determine what character might emerge:

1. You are speaking at the memorial of a close friend who died tragically at much too early an age. The mother of your friend is overcome with grief and you need to touch her heart somehow. You decide to tell her something amazing about her daughter that she never, ever, knew. Use these words to lift her heart and spirit and get her to smile with joy at what an amazing daughter she had. What character will the director see if you are successful in playing that?
2. You are the best man at the wedding of your closest friend. Unbeknownst to your friend, you had a brief but impassioned romantic encounter with the bride just months before the wedding. The bride has lived in terror that her new husband will learn of this tryst and it will poison their marriage. Use these words to tell her, in code, that you will never, ever, betray this confidence because you love them both. What character will the director see if you are successful in playing that?

The point here is that it is the energy with which you use the words to comfort the mother or assure the bride and not the word symbols themselves that create the behavior that reads as character to the director and other people watching you. You are using the words to get the mother to lift her eyes and feel joyful, but the people watching you label your behavior and call it a character. If your energy is right, you should be able to make the mother lift her eyes and smile at you by saying, "Two, three, and nineteen saucers lying on the moon, and he said, 'what does the moon say to me?' And I said, I love the moon, especially for dessert." Open scenes teach you not to play the words or the story. The WORD SYMBOLS might be about a sports-betting APP, but the energy and action and specific point of view provide two entirely different "takes" on the spot.

Yogurt Advertisement

Eight women in separate shots:
WOMAN #1: *(holding a baby on a park bench)* Oh, hey, it's me. MOM. Out here in public. Catching some side-eye. First rule of motherhood. Someone's always judging.

WOMAN #2: *(feeding child with a bottle) Breastfeeding didn't turn out. Guess What? World's still turning.*
WOMAN #3: *(in an office) Go to work. . . . I'm MISSING his childhood*
WOMAN #4: *(in a child's room) Stay home, I have no AMBITION.*
WOMAN #5: *(with children eating snacks) Yea, I bribe my kids. How else do you think things get DONE around here?*
WOMAN #6: *No, I'm not the grandma. Do I look like the grandma?*
WOMAN #7 *(holding a glass of wine) Mom's special juice: It's WINE*
WOMAN #8: *(wearing yoga pants) Yes, Yoga Pants. BIG fan.*
WOMAN #9: *(with low cut dress): Too much? How do you think I got the name MOM in the first place?*
WOMAN #10: *(straight into the camera feeding yogurt to her young child) Now, if you think that's shocking, check this out. Good old-fashioned Mom's yogurt. It's not made with cage-free Norwegian hemp milk. And GUESS WHAT?? She LOVES it. Do what tastes right!!*

Play It Like an Open Scene

The obvious target of this advertisement is child-bearing age women who are tired and resentful of unwanted, contradictory "messages" from people about their life choices. The last woman speaks the theme of the commercial when she says, "Do what tastes **right**," instead of doing what everybody else tells you to do. Without doubt this would be explained to the actresses auditioning for the spot and each woman would be handed a different line to read. Most actresses are going to look to the line and then play their *general* sense of it. Since **all of these lines <u>*generally*</u> express a resentment or rejection** of some implied expectations put upon these mothers, most actresses will play it that way; *generally* resentful and *generally* refusing to cooperate with an expectation, *generally*. The actresses see the line as an expression of how their "character" feels about the expectation. So, "yes, yoga pants. BIG fan" becomes a retort to somebody who is commenting on them, and 90% of the auditioners will read the line that way. (As if the lines were "Okay, you hate them, but SO WHAT, I don't care what you think.") This is playing a reaction instead of an action and will result in a very *general* character, very similar to what most of the other actresses who are auditioning do. In fact, most actors play *general* energy, and one of the benefits of open scenes is that it is impossible to play *general* energy because the words don't mean anything until the actor gives them a specific meaning.

How does work with open scenes help the actress create a character for this one-line audition? Open scenes teach that a character only happens when an actor *does* something to someone else (i.e., get them to respond in a certain way). Open scenes teach the actor that the line has to be about

the other person and not about the character she is trying to portray. Open scenes teach the actor to invent a premise and use the line to get a particular response and/or to change the other person in the premise. Thus, the "meaning" of the line is whatever is necessary to get the response you want. To the director of the commercial, it will look like an interesting "reading of the line," because she has no idea of the premise the actress has created.

Exercise: Premise, Point of View, Action

Look at each line and create a premise that involves a specific relationship and decide how you are going to use the line to get a specific response from the other person in the relationship. As an example, let's look at Woman #2. "Breastfeeding didn't turn out. Guess what? World's still turning." Most women auditioning will take their cue from the line and make this a statement about pride in breastfeeding (or something like that). So, the reading (you guessed it) will be general. But, in the spirit of an open scene, let's invent this premise: The woman in the scene is in conversation with her friend who is despairing about her marriage that is ending. The woman cares deeply about her friend and realizes that her friend needs the courage and hope to move on with her life. The woman has survived breast cancer and now sees an opportunity to give her friend a boost of courage by creating a bond between them. So, she picks up her child (who she cannot nurse because of her mastectomy) and electrifies her friend by saying, "Breastfeeding didn't turn out. Guess what? World's still turning!!" The premise means that the line is not about breastfeeding, it is about getting the friend of the woman to get up and start her new life. The director of the commercial will say to herself, "Hmmmm . . . interesting reading of the line; I like the energy of that character."

So, the actress auditioning for Woman #3 can utilize emotional packing to liberate her imagination in countless directions. For example, perhaps Woman #3 is "this close" to walking off the job and doesn't need any crap from her supervisor. Her line: "I'm missing his childhood" now means, "Don't push it. You need me more than I need you." Maybe Woman #9 is getting ready for a long-awaited and much-anticipated night on the town with her husband. She sees his reaction to her dress and says, "How do you think I got the name MOM in the first place?' Which really means: "Tonight, we get back to being a couple." The point is that you imagine a situation in which your line is a direct and effective response to that situation. Just as the potential situations are endless, so too, the "meaning" of the line is endless.

One more example of how experience with open scenes can vitalize commercial auditions can be seen by looking at the last lines of the advertisement spoken by Woman #10. This is a straightforward product pitch that

actually uses the brand name and ends with the tag line, "Do what tastes right!" The director will have about 20 other actresses reading that line and will give the job to the person who creates some kind of character and reads the line well (in other words, the one who is specific rather than general). Remember, you will be specific when you know *precisely* what response you want from the other character. The actress who has used open scenes knows that you can't make much of a character by simply saying the words of a product pitch with energy. Instead, the actress handed Woman Number #10 should treat it just like an open scene.

First, let go of the idea that the words "require" you to make the premise about yogurt. Instead make the lines address/solve the problem in the premise you create. Let's imagine this premise: your daughter has been taunted and humiliated by the "cool" girls in her high school because she is overweight and her clothes are not up to the standards of these girls. Your heart is breaking for your daughter as she sobs on her bed. Use the words given to Woman #10 to make your daughter feel the love and pride you have in her and get her to celebrate with you that her hair and eyes and body and clothing and everything about her are BEAUTIFUL. Get her to sit up on the bed and smile as you both fight the "cool" girls together. The WORD SYMBOLS might be about Yogurt, but the energy and action are about a bonding between mother and daughter. For practice use another actress who will play the daughter and make the words pull her up out of despair and into celebration with you.

> *Woman #10 (straight into the camera feeding yogurt to her young child) Now, if you think that is shocking, check this out. Good old-fashioned Mom's Yogurt. It's not made with cage-free Norwegian hemp milk.* (As if the lines were "Now when you get up from that bed, you are going to stand next to me, look straight in that mirror, and say, I don't give one damn whether they think I am cool or not!!")
> *And GUESS WHAT?? She LOVES it. Do what tastes right!!* (As if the lines were "They better hide somewhere, because YOU ROCK, and NOTHING will stop you now!"!)

And, it probably won't hurt if you just happen to hold the yogurt container in such a way that the audience can read the label. It is, after all, a commercial.

Change the Premise and Point of View to Change the Character

Or, what about this premise? You are a successful businesswoman who has been urged to run for political office. You have never felt called to do this, and besides a woman has never served in Congress from your district. Despite repeated attempts to get you to join the race you have always

refused. Today you are speaking in front of a group of business men and women and you use the words given to Woman #10 to announce your candidacy. Use the words to both shock the audience with surprise and get them to leap to their feet and applaud your announcement.

> *Woman #10 (straight into the camera feeding yogurt to her young child) Now, if you think that is shocking, check this out. Good old-fashioned Mom's Yogurt. It's not made with cage-free Norwegian hemp milk.* (As if the lines were "I am about to say something that will blow you away. And it isn't about business or marketing!")
>
> *And GUESS WHAT?? She LOVES it. Do what tastes right!!* (As if the lines were "I am running for Congress, and I need your help, and I INTEND TO WIN!!"

In both of these exercises the goal is to make the words specific and purposeful. They will be specific if you know *exactly* what you want your daughter or your audience to do. The director of the Mom's Yogurt spot will only know that she likes your energy and your "reading." You have created two characters: the inspirational mother and the exciting new political candidate. All because you know how to employ the lessons of open scenes in your work.

In the next chapter, we turn to another essential skill for the actor. Working creatively with short scenes or "sides" for film and television roles is critically important to the 21st Century actor. Not surprisingly, the same things we used to make commercial copy come alive for an actor will be utilized in successfully engaging film and television copy.

NOTE: Today, more than ever, commercials are often mini-dramas that establish a problem the product is intended to solve. This makes the lessons learned working on Open Scenes even more valuable.

5 Open Scenes and the Day Player

Film and Television

> DAY PLAYER is a contractual designation by SAG-AFTRA, the union that represents screen actors and others in electronic media. As the name implies, the Day Player is contracted for a single day's work. While the actor may work multiple days on the same project, there are limits as to how many days in a week they may work before converting to a weekly contract. For example, if there are multiple stars with whom the Day Player's character interacts, it's possible these stars will be filming on different days. In that case, it is more cost-effective for the production to "drop and pick up" the Day Player for the actual time needed. Union members are eligible for residuals for additional usage of their work including television reruns. Pay scale is based on production budget.

To begin this chapter, we thought it would be helpful to hear from a working actor who deals on a daily basis with audition material for film and television. We asked Los Angeles based professional, Kevin Brief for some advice on preparing and performing scripts for television and film. Kevin is active in live theatre and has over 100 film and television credits. Check him out at www.kevinbrief.com

Interview with Kevin Brief

1. How do you get the "sides" for film and television roles? Do you just get your section/scene or do you have access to the larger script/screenplay?

 When my agency secures the audition, they will attach the audition sides in their email and they send to inform me of the details of the audition

DOI: 10.4324/9781003242444-6

including date, time, location, etc. I always depend on my rep to get me the sides, although there is a service called Sides Express that may have the sides for the project available. If the audition comes directly from a casting director, they will most certainly attach the sides in their email.

In general, it is rare to get the entire script, particularly in television. For television auditions, an actor gets the entire script only for a major recurring or guest star role. If the project is a pilot for a new show, you will most likely get the entire script. Feature films will make the entire script available more often than television but still only about 25% of the time. So, sides are the most common way that an actor is given an audition opportunity. Sometimes you will not even get the "real sides." Depending on the project's level of security, you could have a "fake scene" with which to audition. The scene may be reminiscent of the true action ... but character names, locations, plot lines will be changed from the true ones.

2. How is the character for which you are auditioning explained to you? What information are you given about the character and context and the other characters?

 There is a company called Breakdown Services. What they do is read the script and gather character descriptions and the basic story. They then create a document called a "breakdown." That is then sent back to the casting director for their approval. That "breakdown" is then sent out to agents, who then submit actors for the appropriate roles. When/if the agent secures an audition for me ... I will be sent the appointment information along with the corresponding "breakdown" and the sides. At the very least, I will get the "character breakdown" for my character ... and often, the breakdowns for all the characters that are being cast. For my research, I look for any clues about my character within the other character breakdowns. If I happen to get sides for other characters, I will read them for any info I may be able to glean. Usually, these won't be sent to you, but there is a good chance they will be available when you get to the casting director office. If so, I will take the time to peruse them.

3. How do you determine what they are "looking for?" and/or how do you make choices for playing the scene? Do you get feedback? Do they "work" with you or ask for changes/adaptations?

 Aye, there's the rub! What are they looking for? In one sense, it is a bit of a guessing game, and it is also a bit of a trap. Pretty much every actor begins the audition process by thinking "what are they looking for?" The fact of the matter is ... we have no idea! The best an actor can do ... is do all the research and preparation mentioned earlier and make your choices as you work on the scene. You simply want to

create the most compelling take on the scene that feels right to you. In essence, your job is not to guess what they are looking for . . . nor even to get the job. Your job is to bring you and your talent into the room. If you do that, there is a good chance the casting director will know it, and whether you made the "correct choices" or not is not as important at that moment. They will indeed give you notes to lead you more toward "what they're looking for," or they will give you adjustments/direction on what you have done. That being said, if you have questions, do ask them before you start the audition.

4. What advice would you have for actors in working with sides (like the ones you sent me)?

Aside from all that has already been mentioned . . . I also always look for moment where "I can zig, while everyone else auditioning may zag." I also look for humor. It might or might not exist in the scene . . . but I will mine it a bit if possible. Memorize the scene. You should hold your script in the audition, but the more you are off the page, the better. Most audition sides are short enough to be "off book." But, DO hold your script no matter how well you think you have the lines down. Everyone knows this is an audition, a final performance is not expected.

The Lesson From Kevin Brief: Never Play the Story

Kevin Brief has said some important things that correspond nicely to the work in which we are engaged in this book. In the first place, he confirmed that "sides" are the most often-used manner in which actors audition for film and television. In his experience, 75% of the time he has not been given the full script and has only the sides and very basic information on the character for which he is auditioning. Even more challenging is that often the sides themselves are disguised or substituted for the actual script and therefore have no connection whatsoever to the actual story. It's hard to imagine a better example of how critically important it is to play action rather than story than a situation where the story has no inherent value to those casting the show.

As we shall see in this chapter, this emphasizes the futility of trying to play the story implied by the words. You as the actor have no real idea of the "big picture" of the film or teleplay nor are you given any real depth or context for the scene you are reading. As Kevin Brief said, the actor has no idea what the casting people are "looking for." They will hire the actor who gives the most compelling take on the scene. In this chapter, we will demonstrate that <u>you must</u> create a context and premise for the sides and that the more specific and compelling your point of view and premise are,

the more compelling you will perform for the casting director. Remember that the art of acting is not the interpretation or speaking of the lines. **The art of acting is the ability to use your imagination to invent a vital point of view and an engaging premise and then use positive, effective energy to change the other person.**

> SIDES. In earlier times, scripts were either copied by hand, which was painstaking and time-consuming and could lead to errors when not copied accurately. Also, to protect their scripts from being pirated by rival companies before copyright laws were enacted, authors provided individual actors only a copy of their lines with the few preceding words to cue them in. In effect they were only given their "side" of the scene. This is practice was common in musicals into the late 20th century.

Working With Sides as Open Scenes

As the interview with Kevin Brief suggests, auditioning for roles in film and television most often involves the actor getting sides from their agent or the casting director of the project. Unlike a script that contains the entire dialogue of a scene, a side focuses on only one character and provides cues for that character only. In contemporary film and television auditions, the actors are sent these sides because the casting people are only looking at this one character, so the actor needs to take what is given to them and do the best they can.

Approaching sides in the same way as an actor works with open scenes is a very effective way of overcoming the difficulties presented by the limited nature of sides. A side is almost always drawn from new material, the part is often small, and the sections of dialogue are tiny and/or secondary to the main theme of the scene or episode. The character in the side is often undeveloped and may really not be very clear in the mind of the casting people. To add to these difficulties, the actor may only be given a few minutes to familiarize themselves with the side, and the character may be very general: a delivery man, a doctor, a driver, a customer, a mother, etc. In other words, sides frequently give the actor no more specific information than does an open scene. Ah . . . *now THAT should be music to your ears.*

What working with open scenes has demonstrated is that it is up to the actor to create a specific character by inventing a premise and a conflict that produces distinct and purposeful behavior. This is what the casting people are looking for; someone who brings personality and something interesting

to the side. Most often in a side, it is the actor who defines the character and gives humanity to generic-sounding descriptions. An actor experienced in open scenes knows that there is no such person as **A** mother or **A** driver or **A** doctor or **A** delivery person. Even though the character is described in generic ways, this is a tremendous opportunity for the actor to use open scene techniques to transform "A driver" into a specific and unique human being.

> NOTE: Another piece of good news is that often the casting director isn't even looking for a specific "type"; that is, not "a young Brad Pitt" or an "Amy Adams type." If you demonstrate that you have what it takes to play the action in this scene, they likely won't really care if you have a bald spot or are a little overweight. In other words, all the things that might work against you when auditioning for a leading role might actually work in your favor in fleshing out the realistic world the production seeks to create.

Just as is the case with open scenes, a side gives very little useful information and has virtually no context for the lines written on the page. So, the trap is the actor will simply look at the words to get a general sense of what they suggest or "mean" with the result being playing only the most obvious (and general) qualities of the side, just the minimal amount to serve the purpose of the scene (deliver a plot point, evoke a particular response in a major character, etc.). The side may suggest to you some aspect of a relationship and perhaps a glimpse of the situational context, but just as is the case with a second-tier open scene it gives you neither a complete story nor any depth of explicit understanding of the people in the scene. It is up to the actor to create the context, the story, and the character. The more specific the premise you create, the more specific behavior you will produce, and the more specific the behavior, the more specific and successful the character. This is what open scenes teach us about working with sides:

- Don't try to use the lines to play the story; the lines are not sufficient because they lack any context as the side is very short.
- Use the lines as an opportunity to invent a premise. The premise is not drawn from the lines rather the lines are used to solve the problem of the premise.
- The premise must contain conflict so that the side is about attempting to resolve the conflict in the scene.
- The more specific your point of view about the other character, the more specific your behavior will be toward them.

Working With an Actual Side

Side One: <u>Parole Board Chair:</u> This side was sent to an actor for a single speech. Typical of many sides it provided no context or character information, nor does it seem to have any conflict. *What a recipe for a terrible audition.* Yet, if we treat it as we would an open scene, we can apply our criteria to transform this side from a generic "Board Chair" into one moment in the life of a very specific human being.

Interior of a prison: conference room meeting of the parole board
A psychologist is concluding her testimony before the parole board.

PSYCHOLOGIST: This man is not a threat to society. In fact, if released, I believe he'd be a model citizen.

The psychologist concludes as the parole board consults with each other. After a moment . . .

BOARD CHAIR: We agree. Parole is granted. (*to the prisoner*) Sir, congratulations and good luck to you. We wish you the best.

Play Like an Open Scene

Here is an audition for a role that contains only one line with 17 words. What in the world can anybody do with that? Most probably the actor would have only a few minutes to prepare and then the audition would take place. How can any meaningful audition happen when all the actors are given one line that is seemingly obvious and without context or texture? Yet, even this is an opportunity to differentiate yourself from the other actors auditioning for the role. Every actor trying to get this small role will conclude the obvious; this is a parole board granting release to a prisoner and wishing them well. And, most actors will also play the obvious, which means they will simply use the lines to convey information to the prisoner that (he) is released and that the board wishes him well. This means that almost every audition will sound pretty much the same because there is nothing specific in the language that gives the actor any opportunity to project a character. Unless, of course, the actor is experienced in using open scenes. In this case, the poor casting director will be reduced to hiring the actor who simply "looks like the head of a parole board." You can offer more.

If we took this very short scene and imagined it as an open scene, we would need to invent a specific premise that incorporated conflict of some sort which allowed the actor to use the words to address the conflict in the

situation. Once the actor is handed the script, he can quickly transform it into an open scene by doing these very things. Let's imagine this:

Premise: You are the board chair and the entire board has voted in favor of the release of this prisoner over your strong objections. Every bone in your body tells you that this prisoner is manipulative and dishonest and will continue to be a danger to the public once released. But, since every other member of the board disagrees you have been forced to relent and allow the majority to have their way.

Objective: When the prisoner arrives, you must tell the psychologist that the board agrees with her assessment. Then you face the prisoner directly. Use the words to make the prisoner look directly in your eyes. Give him a warning that everything he does will be watched and that the first wrong step he makes you will be ready to pounce. Make him promise to dedicate his life to living within the law.

This gives you a very specific point of view about the prisoner (that he is a con-artist) and very specific behaviors (you put the fear of God into him). Notice that you are using the lines to address the premise rather than creating a premise based on some general sense of the lines. The words "congratulations and good luck to you . . . we wish you the best" (if interpreted literally) would never seem to be a warning about anything. But, look how specific and interesting your "reading" of this line will be because you have treated the side like an open scene.

Exercise: Play the Action of the Line Using Paraphrase

> ***Sir, congratulations and good luck to you.*** (Listen, buddy, don't fool yourself, both of us know you just lied your way out of here.)
> ***We wish you the best*** (Every step you take, I'll be there watching . . . and waiting.)

Notice how you use the word symbols the script gives you to do the work that premise demands. You never, ever, play the words.

Taking Direction

But, as often happens in an audition, what if the casting person says to you, "No, that is coming off too angry, can you make him a little lighter and genuinely pleased that the prisoner is getting parole?" What will most actors DO when they get that direction? They will simply take the lines and say them "more pleasantly." In other words, they will just play the lines in a different way. Using your work with open scenes however, you can give the casting people a much more specific and interesting audition by making a few adjustments; changing the premise, changing your point of view, and changing your behavior.

Premise: You have personally led a campaign to acknowledge the tremendous good that this prisoner has done while incarcerated. He learned to be a legal aid and helped numerous other prisoners with family legal problems, and he counseled young offenders and encouraged them to develop new skills and hope for a life after prison. But, he has been in prison so long that he has fear and anxiety about the world outside, and has begun to seriously doubt he can make it "out there."

Objective: After the Psychologist gives her opinion, you have the chance to say one last thing to this prisoner before he enters the outside world. Get him to look you in the eye. Then, make him feel the way you (and the board) feel about him. Get him to burst with confidence as he sees in your eyes that you are absolutely sure he will succeed in the world.

Exercise: Practice Playing the Action Using Paraphrase

Sir, congratulations and good luck to you (My fellow citizen and friend, by God you have EARNED it.)
We wish you the best (You will do GREAT things).

And maybe when you show up on set, the director (who may not have been involved in the casting process) says, "It's just business as usual. Don't do anything." Well, perhaps one of the situations you rehearsed on your own includes the idea that you've already been at this for five hours and this case is a no-brainer and there are two very complex hearings yet to come. In this case, perhaps you deliver these lines not just to the prisoner, but to your fellow board members and the attorneys as if to say, "We're all done here, right? Moving on." And literally turn the page to get to the next case.

NOTE: The number of plots in the world is limited, and virtually every story is a variation on one of them, so the reason we watch again is for the specifics of this particular version. In other words, we're interested in the writer's take on it, and we want to see what a particular actor brings to it, what only you can bring. One of the advantages a new actor has is that we haven't seen her before (or not very often), so your lack of experience can actually work in your favor. We've seen "people" in this situation before. Perhaps we've even been in this situation ourselves, but we haven't seen YOU. The reason the story and the characters hold our attention is that the specifics of this particular iteration might provide new insight for us or engage us in a novel way. The universal is illuminated from the specific, so BE SPECIFIC.

Working With a Short Television Scene

SIDE TWO: *Meredith and Christine*: Here is a short television audition scene for two young women. Typical of a television audition, this is a scene in which the script provides the outlines of a relationship but virtually no context other than two women skirmishing over kitchen hygiene. Some things in the scene are obvious. The two women live in the same apartment or house, they are young, and a confrontation of some sort takes place revolving around kitchen chores. Every actress auditioning for this television show will be able to arrive at that conclusion, but unfortunately for them, most will also fall into the trap of playing the story that seems evident from the lines. The result will be a *general* audition in which the actresses use the lines to *generally* illustrate the story of two women *generally* scrapping over dishes and garbage, *generally*. In other words, they won't get the role because they are not bringing to the audition anything other than the obvious.

If, however, the actresses approached this script as if it were an open scene, they would have a much better chance to land their roles because they will have invented a context and situation that makes this scene very specific. And, if the context is specific, the situation will be specific, and the resultant behavior of each woman will be specific. The more specific the behavior, the more distinct each character becomes.

CHRISTINE: Heyyy.
MEREDITH: Hey.
CHRISTINE: So, I was thinking that it would be cool if you maybe cleaned your bowl after you used it?
MEREDITH: What is this passive aggressive bullshit?
CHRISTINE: I'm just trying to encourage hygiene. Whatever.
MEREDITH: Well, my bowl is not your problem. I'm an adult. Fuck hygiene.

Meredith picks up a dish, dumps food in the garbage which is overflowing, pushes the garbage down which takes all her strength and then wraps the dish in tin foil.

MEREDITH: *(Continued)* From now on I only use one dish.
CHRISTINE: That looks like just as much work as emptying the garbage and cleaning your dish.
MEREDITH: Well it isn't.

She then takes a piece of pizza from a box on the counter.

CHRISTINE: That's from last week.
MEREDITH: Actually, it's from last month.

CHRISTINE: It's kind of moldy.
MEREDITH: News alert: cheese is MOLD. Boom.

Meredith takes a defiant bite. Then has trouble chewing and swallowing it.

MEREDITH: Delicious.

Play It Like an Open Scene

The easiest thing to do, of course, is to play the scene "as written" and make it conflict about dirty dishes in the kitchen. Certainly, that is what the *story* is about. But treating it as an open scene allows the actors to create a conflict much more interesting and engaging than simply fighting about cleaning up the kitchen. Working on it as an open scene is an opportunity to make the scene more compelling than the story so that the *words* might literally be about the dirty dishes and the garbage and the pizza, but the *action* is about a more important conflict. If the actress auditioning for Meredith were handed this audition scene, she could employ her open scene skills to create a premise with a deeper conflict than dirty dishes so that the two women would actually be skirmishing about something far more specific and meaningful than whether or not one of them should clean out their bowl. Using the words in the scene to address this deeper premise will make Meredith more specific and far more interesting. Remember that this is an audition side and the casting people are looking for the most interesting people. If the premise is compelling and the behavior needed to address the conflict in the premise is compelling, the actors will appear more interesting.

Let's imagine that the actress auditioning for Meredith looks at this side and decides to play it as she would work an open scene. She uses her imagination to create a compelling premise with a conflict and a specific point of view about Christine.

Premise: Meredith and Christine are roommates and were once close. But over the past few months they have grown apart as their social and political ideas have diverged, and they have recently developed completely different kinds of friends. A few days ago, they had a verbally violent confrontation and have not spoken since. From Meredith's point of view, Christine is being manipulated by her partner and his friends who are social and religious fundamentalists and highly judgmental. In an effort to win their approval, Christine has adopted what Meredith sees as rigid and angry positions on Meredith's behavior and her friends. In the confrontation, Christine accused Meredith of becoming dishonest, sexually irresponsible, and "too into the drug scene." In turn, Meredith accused Christine of being hypocritical and "a religious fake." Meredith is absolutely certain that Christine doesn't really believe anything she currently espouses.

58 *Open Scenes and the Day Player*

Objective: As Meredith meets Christine in the kitchen, she sees an opportunity to break through her friend's pretending. Use the words in the scene to make Christine admit that she is faking all this and get her to apologize for attacking you the other day. Win your friend back and reclaim your relationship by breaking down her walls of denial. A little shock, and her false pretense will collapse. You want your friend back and you KNOW that she does also!

Notice how the premise determines what you will do with the words in the scene, rather than the words determining what you will do in the scene. Each line now becomes an opportunity to get that apology from Christine. On the surface the words, "well my bowl is not your problem, I'm an adult," seem to convey information about hygiene and maturity with some sarcasm. Certainly, most of the other people auditioning for the role will do exactly that: make a sarcastic statement about the dirty bowl. But in this premise, the actress playing Meredith uses these words for a much more specific purpose. She uses them to turn the mirror on Christine so that her friend can see what she looks like when she is cold and judgmental. On the surface, the lines "News alert: cheese is mold, boom," would seem to be a belligerent retort to Christine's criticism about eating a stale pizza. In this premise however, Meredith uses these words to shock Christine, to turn the lightbulb on in her head that allows her to see what she is doing to herself. When she DOES finally realize what she is doing to Meredith and herself, she will apologize.

Exercise: Play the Action Using Paraphrase

Considering the premise we developed, use paraphrase to help you play the action of the line. Get her to admit she is lying to herself. Get that apology!

MEREDITH: **What is this passive aggressive bullshit?** (Did you hear what you JUST SAID?)
CHRISTINE: **Well my bowl is not your problem. I'm an adult. Fuck hygiene.** (This is not about me or my bowl or the kitchen, is it Christine? You are better than this. Stop pretending!!)
MEREDITH: **News alert: cheese is mold. Boom** (Ah . . . Gotcha!! The REAL Christine LOVES old pizza, and you know it. Admit it!)
CHRISTINE: **Delicious.** (Now, apologize, damn it!!)

It should be obvious by now that working with open scenes changes forever how an actor understands the role that words play in a script. Hopefully, it is also clear how a script can "play" an actor and make them a prisoner of the story. The message always is that the word symbols are pliable and their meaning is entirely dependent on how the actor uses them to try to solve conflict in a scene. This can be illustrated by using the same side and the

same words with Meredith and Christine but changing the premise and the conflict. If the premise changes, then what the actor does with the words will also change.

Taking Direction

Let's use this new situation. Imagine that the casting person wants this scene to be light and fun instead of tense and combative as we found in the previous premise. What does an actor do with that direction? Does she just say the lines with a light and fun quality? Does she assume that if the scene is light and fun that means there is no conflict? Do they just do the lines "as written"? The main message of this book is that open scenes teach the most important lesson that the actor can never play the words or look to the words to get "meaning." So, when the casting director asks for a different tone or feeling, the only choice for the actor is to change the premise, the conflict, and the point of view. Let's do just that.

Premise: Meredith and Christine are good friends and college roommates. They are both in their senior year and lived together since they were freshmen. For over a year they have dreamed and planned to spend the spring break in their senior year in Florida. Two weeks before spring break, Christine suddenly backs out because she wants to stay home with her boyfriend instead. Meredith is appalled and immediately launches a campaign to change Christine's mind. It is now two days before spring break and Meredith has to pull out all her ammunition to restore their Florida trip.

Objective: As they meet in the kitchen, Meredith decides that now is the time to act. Meredith is going to change Christine's mind by making her realize how MISERABLE it is going to be in their apartment if they blow this Florida beach trip. Her point of view is that Christine desperately wants to go to Florida but that she is caving to her boyfriend. She knows that if she pushes the right buttons on Christine, she will get her to change her mind because their friendship is just as important to her. The actor playing Meredith must use the lines to get Christine to relent and recommit to going together to Florida.

Once again, the premise and the objective determine what the actor will do with the words. The words are weapons of war to get Christine to relent. The point of view is important because it is Meredith's feelings about who Christine is that gives Meredith the confidence that her tactics will work. This side is now an open scene because it has a premise with a conflict: (Meredith wants to go to Florida, and Christine does not) and it has a clear objective (Meredith wants Christine to promise she will recommit to the Florida trip), and it allows the scene to be very specific.

Exercise: Playing the Action

Using the premise and the objective, determine the action of each line in the side. What are you *doing* with the word symbols to get Christine to finally say "Ok, stop it. You win. I want to GO TO FLORIDA with you." Don't play the words, bend the words to make something BIG happen to Christine. For example,

From now on, I only use one dish: What are you trying to get Christine to do here? Get her to picture what a spring break without Florida will look like. Your single bowl will continue to grow more vulgar and disgusting until the entire kitchen STINKS. Get her to envision you not washing your hair, brushing your teeth, or EVER changing your clothes. Fingernails on the blackboard until she relents. Make this happen to her with the words, **"from now on, I ONLY USE ONE DISH!!" (And make clear the "the dish" is a weapon you will relish bringing to battle time and again.)**

Actually, it's from last month. News alert: cheese is mold. Boom: Try saying the paraphrase: "and I will continue to gross you out every day until you say yes!!" Then use that same energy but say the word symbols the side gives you. Now, there is a specific and purposeful reason to grab the moldy pizza and eat it in Christine's face. (She will FINALLY give in and agree to go to Florida). The casting people will not know you did all this work, but they WILL see that your audition is more interesting, has more energy, and gives them some sense of a character.

CSI: Open Scene

SIDE THREE: *Bail Bondsman*: Television seems to have a limitless appetite for procedural crime dramas. The extraordinary popularity of series, such as *Law and Order, CSI, NYPD Blue, NCIS, and The Mentalist*, means that actors are continually auditioning for this kind of material. Here is a side sent to two actors in which two modern bounty hunters are having a conversation. Read this scene as if you are auditioning for one of the two roles, and then let's discuss the challenges in auditioning with this side:

> *Bobby, an older and somewhat disheveled bail bondsman, is smoking a cigarette as he pours a cup of coffee for Renee, a younger officer. She takes the coffee and smiles at Bobby. Then she sniffs her armpits; clearly relaxed around him.*

RENEE: I'll get my license back, right?
BOBBY: Sure, you got your man . . . dead or alive.
RENEE: God bless America.

Renee grins and toasts him. Bobby doesn't look so relieved.

BOBBY: It's not the Department of State I'm worried about. Salina's friend. Recognize him?

She shrugs.

BOBBY: Alberto Sanchez.
RENEE: He plays right field for the Dodgers, right?
BOBBY: He is the son of Manuel Sanchez. The head of the Centavo Cartel.
RENEE: Ah. Shit.

Bobby grabs some papers and shows them to Renee. They are from the New York Times showing Alberto Sanchez, holding an automatic rifle, standing on a massive stack of cash. The Headline reads: "Textbook Screw-up."

BOBBY: He is the stupid ass who gave away the location of a safe house on Twitter. It was like a roadmap for the Mexican army, and they raided it. It cost the cartel hundreds of millions.
RENEE: And Sanchez didn't kill him?
BOBBY: He was his son.
RENEE: That doesn't mean crap to these animals.
BOBBY: You sure about that? You need to disappear for a while, Renee.

A slow look of fear creeps into Renee's face. Bobby reads it.

BOBBY: When the insurance pays out on Salina, I'll give your cut to Lizeth.
RENEE: You're a good man, Bobby.
BOBBY: I can get you out of jail. I can't get you out of the morgue.

Not Enough Story? Play It Like an Open Scene

Of course, the first thing any actor does is read the side and try to determine what is happening. To the extent that there is a "story" it seems clear that Renee and Bobby are in the bail bond business. In most states, a bail bondsman (Bobby) works with and compensates a bounty hunter (Renee) to track, locate, and return fugitive criminals who have jumped bail. In this side, it appears that Renee has brought in a fugitive who is the son of a powerful drug cartel leader. Bobby informs her of this and tells her that she needs to go into hiding. That is all the side tells you.

What are the challenges? This is all the actor playing Bobby has to work with. He is telling Renee that she is in trouble and that she needs to seclude herself. How will the actor differentiate himself from 15 or 20 other actors reading for Bobby? There is virtually nothing in the words that gives the actor

anything to play except Bobby delivering the "facts" to Renee. So, the actor does his best to look and sound "disheveled" and he reads the lines trying to squeeze whatever he can out of them to give some sense of the character.

OR, he could play the side as if it were an open scene. Obviously, there is a basic situation here surrounding the apprehension of a fugitive, so the actor isn't going to invent a premise that makes the scene about the 1991 World Series or the breakup of the Beatles; however, the side has so little context that whatever conflict might exist between the two characters is not readily apparent. (And remember the premise must have conflict.) This gives the actors the opportunity to create a scenario that allows him/her to use the words to change each other in some way and resolve the conflict in the premise. Invent circumstances in the relationship between these two that make this scene necessary so that Bobby isn't just announcing the facts to Renee to which she agrees. If the relationship is more specific and the premise is more specific, the actors will be more specific and his character will be clearer to the casting people. This is the job of the actor.

> **NOTE: Conflict is the essence of drama. No conflict; no drama.**

Premise, Point of View, Action

Premise: Renee is a single mother who has lost her child to her ex-husband because of her drug problems and heavy debt load. She has turned to bounty hunting as a steady job, and apprehending this criminal is the accomplishment that will prove her professional success and convince the court to return her daughter to her. Bobby is her friend and mentor and persuaded her to become a bounty hunter. Now, just as she is about to win back her daughter with the money from bringing Sanchez to justice, Bobby has to tell her the bad news.

Objectives: Bobby has to get Renee to agree to give back the money and go into hiding by persuading her that her life is in danger. Renee has waited for this day to regain her daughter and NOBODY, not even tough old Bobby can tell her anything that will change her mind because today she starts a new life. Bobby has to overcome Renee's passion and dream for her new life and get her to accept/endorse giving it up. Renee has to get Bobby to agree to find a way around this problem that allows her to keep this money. Get him to promise that he will find a way to make that work. Both actors need to use the words of the scene to make the other person do what they want.

Notice what happens once the relationships and situations are specific. Bobby knows how much Renee needs this money, so he needs to create

Open Scenes and the Day Player 63

enough alarm in her so that it is stronger than her desire for the money. He is fighting for her life. Once Renee understands that Bobby is telling her she must give up the money, she must get him to promise he will work around the drug-lord problem and get her what she earned.

For the actor playing Bobby, the following lines are critical to get her to grasp the gravity of the situation. Given the premise we have created, Bobby is not just informing her about the identity of Sanchez, he is choosing his words carefully to create as much terror in her as possible so that she has no choice but to go into hiding. Use the lines to make that happen to her.

BOBBY: **It's not the Department of State I'm worried about.** (How scary is it if it is worse than the Feds after you?) **Salina's friend.** (Make her know that this was NOT his friend). Recognize him?

She shrugs.

BOBBY: **Alberto Sanchez** (make that name resonate in her heart like Charles Manson or Jeffrey Dahmer or Keyser Soze).
RENEE: **He plays right field for the Dodgers, right?**
BOBBY: **He is the son of Manuel Sanchez . . . the head of the Centavo Cartel.** (Make her picture men who rape the women before they kill them; who make parents watch as they kill their children.)

For the actress playing Renee, the lines are critical to her ability to get Bobby to care more about their friendship than his concern about drug money. With this premise, she is not just responding to Bobby's information about Sanchez, she is using it to get him to do what she wants.

BOBBY: **He is the stupid ass who gave away the location of a safe house on Twitter. It was like a roadmap for the Mexican army, and they raided it. It cost the cartel hundreds of millions.**
RENEE: **And Sanchez didn't kill him?** (Ask yourself WHY NOT, Bobby)
BOBBY: **He was his son.** (He understands what blood means, and he won't hesitate to go after your daughter if you get her back now.)
RENEE: **That doesn't mean crap to these animals.** (You are braver than they are.)
BOBBY: **You sure about that? You need to disappear for a while, Renee.**

A slow look of fear creeps into Renee's face. Bobby reads it.

BOBBY: **When the insurance pays out on Salina, I'll give your cut to Lizeth.**

RENEE: **You're a good man, Bobby. (You are a man who would NEVER do this to me.)**
BOBBY: **I can get you out of jail. I can't get you out of the morgue.**

What do you do if the casting director asks you to "look more disheveled, like the script calls for?" Rumple your clothes? Perhaps it's a change in the premise that makes Bobby diminished in his own eyes. Perhaps working with Renee is the only good thing he's done in the last 15 years, but he's being squeezed by a dirty cop. He can't tell Renee the truth, because he couldn't stand for her to know what a pig he is. So, he has to scare her to make her go away, which also may save both their lives. Now he's got a dirty, not-so-little secret, and while that doesn't change his dramatic action (getting her to relinquish the money and split), it changes the way the audience perceives him even though we won't really understand what's really going on under the surface.

This premise and countless others can be invented while the actor is sitting waiting for the audition to take place. Just as if this were an open scene, the actor can create a specific situation and point of view of the other character in the scene, and then manipulate the lines to fix the problem in the side. In this situation, the problem for Bobby is that Renee desperately wants and needs the money that may cause her death and it will be Bobby's fault. He has got to fix that. For Renee, the problem is that Bobby is running scared of the tough guys and is preventing her from getting money that she desperately needs. Maybe this is all complicated because Bobby previously ripped her off, or because Renee is aware that she ripped Bobby off when in the throes of her addiction and has a nagging feeling in the back of her mind that this is just his payback. The possibilities are endless even in a little scene like this. Exercise your imagination to see what triggers the truest, most intense response in you. We all have secrets, so the casting director and the audience don't need to be privy to yours. Experience with open scenes means that the actor has gotten very adept at creating a scenario, point of view, and objective without needing the lines to provide them.

As we will see in the final chapter, this same skill with open scenes is equally valuable in working with scripted work in realism. In Chapter 6, we look at how an actor can excavate a script to understand premise, point of view, and character embedded in the text, and we conclude with the use of open scenes to address specific problems presented by the script in the rehearsal process.

> NOTE: Trigger Warnings are at the forefront of many people's sensibilities at this time, and it's important to make them work for you. A studio, stage, or set should be a safe place, and allowing yourself to be triggered is, after all, the essence of acting; that is, responding truthfully and fully to an imaginary situation. Use your imagination to find the person who will trigger the appropriate response in you to a high degree. Don't imagine someone who will "kind of" gross you out or make you fall in love "a little." The advantage of playing opposite "imaginary scene partners" in auditions is that you get to choose anyone who will bring out the best in you, acting-wise. Your brother may not be an actor, but if he is the one who really pushes your buttons, he will be the perfect partner in certain situations. The same may be true for an ex, a parent, a friend, a bully from your past, etc. You might also choose a particular actor in order to rise to his or her level. In your imagination, Meryl Streep and Daniel Day-Lewis are both available and ready to play.

6 Problem Solving With Open Scenes

Using Open Scenes to Address Specific Problems in Scenes From Dramatic Realism

Now the moment arrives when all the preparation, the exploration of the text, the point of view, and objectives are all determined and the actor begins the process of rehearsal. Can the use of open scenes actually help the actor when working on a scene? Our final chapter examines the ways in which open scenes can be utilized to solve particular problems and challenges in the script.

Once rehearsals begin, open scenes can be an invaluable tool to solve problems posed by the script. This is true because often it is the script itself that can be the greatest obstacle to the actor in building their character. This is particularly true in scenes where the words of the script work against the actor. By that we mean often a scene seems slanted against one character because the story has them losing a fight or because they aren't as confident as the other person or some way are in an inferior position to the other person in the scene. Often, the ending of a scene seems overwhelmingly inevitable, and this is not helpful for an actor. An open scene becomes a problem-solving solution in rehearsal because it frees the actors from the constraints of the lines and allows them to assert their character using words that are not connected to the story of the play. Having experienced this new dynamic, they may be better prepared to pursue the same dramatic action when returning to the script.

Scenes That Present Challenging Problems for the Actor

We will look at four scenes that illustrate how this functions. Although these scenes are from plays, it is important for you to understand that the process is identical in dealing with scripted scenes from film and television. Each of these scenes presents a different challenge commonly found in scenes. In ***The Cherry Orchard,*** the playwright covers the emotional tension and conflict that exists below the surface with lines that seem completely disconnected from what actually is taking place in the encounter. In ***Doubt,***

Problem Solving With Open Scenes 67

> NOTE: Coaching actors in scene work can be problematic when it veers into direction, the purpose of which is to "make the scene better." While making the scene better is a good thing, it is more important in a studio setting that the lessons learned can be applied to making the scene better, and the next, and the next. Keep that in mind as you proceed in this chapter. The point is to glean the principles from the following examples, NOT to solve these individual scenes (which another director might understandably interpret differently in any case).

both actors know how the scene will end, and it is extremely difficult not to allow that knowledge to reduce the scene to an encounter between the one who accuses and the one who is guilty. In ***Proof***, one character introduces a surprise in the middle of the scene that completely overturns the plans of the other. The challenge for the character who has been disrupted is to avoid simply playing anger and resentment. Finally, in ***Angels in America***, it appears that one character wants the scene and the other just wants to leave the room. This is, of course, impossible to act, and so the test for the one actor is to find what he is actually playing in the scene, so that dramatic action is possible.

In each of these scenes, it is crucial that the actors successfully resist playing the implied literal meaning of lines or telling the story and instead remember the lesson of bending the lines to serve their objective. Dramatic scenes are virtually never mere transmissions of information. Otherwise, a Tweet would serve just as well. Even the climax of a "who done it?" is more than simply providing information. As is the case in many plays, the more dramatic a scene, the more difficult it is for the actors to avoid letting the lines manipulate them into playing the story. "Will you PLEASE stop cooperating with the script!!" said the great acting teacher, Manuel Duque. What he meant, of course, is that the temptation is always for the actor to tell the story of the scene instead of playing the dramatic action by trying to change the other person. In the following four famous scenes, it is exceptionally difficult to avoid telling the story unless the actor is highly skilled at knowing how to play an action using the word symbols instead of letting the word symbols play him or her. Using open scenes that keep the characters and objectives the same but remove the particular language of the scene helps the actors develop the energy of action that they can then bring back into the scene. Learning the lesson of bending the word symbols to serve the actor's purpose is the most important element in moving away from story playing into the key task of every actor . . . playing the action!!

A NOTE ON LISTENING. Point of View also works in terms of how you hear what the other person says to you. Depending on your point of view about the other character, even a seeming compliment can invoke hurt or anger if it is perceived as a slight. The more vivid your point of view about the other person, the more it informs you how to listen and respond to what they are saying. You have no control over what the other person says, but you are absolutely in charge of how you receive it. What follows are just a few examples of the potential difference between what is said and how it is "heard." Regardless of the literal meaning of the word symbols, how you "hear" these words depends completely on what you think of the other person in the scene and what you judge to be their motive in saying them to you.

You're beautiful.	You're untalented and dumb. If you weren't gorgeous no one would give you the time of day.
You're clever.	You're shallow.
You're loyal.	People walk all over you.
You're strong.	You bully people.
You're incredibly gifted.	Which is lucky, because you're lazy. Your gifts are wasted on you. If I had your gifts, I'd be amazing.
You're such a hard worker.	You make the most of the little talent you have.
You've got great hair.	Which is good, because it hides your huge nose.

Problems Posed in the Cherry Orchard

In Anton Chekhov's last play, *The Cherry Orchard*, a short, but famous scene takes place between Varya and Lopakhin. The premise of the play is that Varya and her aristocratic family can no longer financially maintain their country estate that includes a beautiful cherry orchard. Lopakhin is the son of a serf who was owned by Varya's family. He has become a successful businessman and despite doing everything he can to keep the family from having to leave, he buys their estate where his father had been enslaved. Throughout the play it becomes increasingly evident that Varya

and Lopakhin are attracted to each other, and even Varya's mother urges him to ask for her hand. The short scene that follows is at the very end of the play as Varya is preparing to leave the estate. They have been left alone so that Lopakhin can ask for her hand.

VARYA: (*examines the luggage takes her time*) That's funny, I can't find them.
LOPAKHIN: What are you looking for?
VARYA: I packed them myself, and now I don't remember where.

Pause.

LOPAKHIN: What . . . ah . . . where are you off to, Varya?
VARYA: Me? I am going to work for the Ragulins. I talked about it to them already; they need a housekeeper. And, look after things, you know . . .
LOPAKHIN: All the way over there? That's 50 miles away. . .

Pause.

LOPAKHIN: Well, looks like this is the end of things around here. . .
VARYA: (*still examining the luggage*) Where are they . . . ? Or, maybe I put them in the trunk. You're right. This is the end of things here. The end of one's life—
LOPAKHIN: I'm going too. To Harkov. Taking the same train actually. I've got a million things waiting for me. I'm leaving Yepikhodov, though. Hired him to take charge here.
VARYA: You hired *who*?
LOPAKHIN: Last year at this time it was snowing already, remember? Today's it's still sunny. Nice day. A little chilly though. . . It was freezing this morning. Must have been in the 30s.
VARYA: I didn't notice.

Pause.

VARYA: Anyway, the thermometer is broken.
Pause. A voice from outside calls, "Lopakhin!!"
LOPAKHIN: (*as if he had been waiting for the call*) Coming!! (He leaves.)

Problem: The Lines Don't Give You Anything

Problem to solve: The biggest problem for the two actors is twofold: first, the literal sense of the lines convey virtually nothing about what is really happening in the scene, and second, both actors know the story, they know

70 *Problem Solving With Open Scenes*

how the scene ends. But the characters don't know how the scene ends, and the challenge is to avoid playing the end of the scene and to make the words active and purposeful despite the seeming disconnect between the word symbols and the emotional reality of both characters. As directors we have seen this scene countless times, and most often both the actors have the end of the scene written all over their faces. ("I know this isn't going to work out the way I want.") So, the scene becomes the moment Lopakhin doesn't ask Varya to marry him. But an actor can't play what his character *doesn't do*, he has to play what his character DOES do. Similarly, Varya can't play, "I'm just waiting for him to ask me to marry him," because that forces her into playing a state of being (waiting) instead of playing an action (getting him to do something).

The director and the actors will have made the decisions about the psychological inner reality of each character. What makes the simple act of proposing matrimony so difficult? The answer lies deeply embedded in their insecurities and how their radically different backgrounds make it difficult to understand each other. Regardless, the moment is at hand, and both of them know what is at stake. Typical of Chekhov, the scene provides absolutely no lines that directly engage the main business of the scene. Everything is "beneath" the lines, and what the characters actually say is supercharged by what they want to say but don't say. In other words, the scene is not about luggage, or what train they will be taking, or even who Lopakhin hired to manage the estate. The scene is about asking the BIG question. That is both the challenge and the main reason using an open scene will be helpful; namely, the literal meaning of the word symbols on the page has virtually no relationship to what actually is being communicated between the two people. It is up to the actors to make the word symbols specific and purposeful, just as was done with the first open scenes in Chapter 2.

For the actors to avoid playing the end of the scene, they must commit themselves to the expectation that things will end with Varya accepting Lopakhin's invitation. Both people are working toward that end. Lopakhin wants to ask for her hand, and she wants to clear the way for him to do just that. So, why doesn't he? Well, in fact he IS trying to ask for her hand but she doesn't recognize it, and she IS clearing the way for him to ask the question but he doesn't recognize that she is doing that. Lopakhin needs a signal from Varya that she desires him, and Varya is giving him the signal in the strongest way she knows. It is their inability to understand the emotional language of the other that causes the scene to end in failure. The task for the actors is to fight to change the way the story goes and make the scene about the moment Lopakhin DOES ask Varya to be his wife. The actors have to make the lines, regardless of their literal meaning, accomplish the task of getting the other person to give them what they need (the signal of desire and the proposal of marriage).

Play It Like an Open Scene

The Open Scene Solution: A director might ask the two actors to improvise the scene, thus freeing themselves of the difficulty of making the words work for them. Often, however, the actors will simply paraphrase the actual dialogue and not learn anything new, which provides another form of failure and exacerbates the difficulty of finding the truth of the scene. That is why playing it as an open scene is much more effective. At first glance, it is very difficult to make a line like, "I packed them myself, and now I don't remember why," which serves the purpose of opening the door for Lopakhin to ask the question. Yet, Varya isn't talking to herself, telling herself something she already knows (I packed them myself). What is she *doing* to Lopakhin with those word symbols that liberate his doubts and get him to ask her? Similarly, how is, "All the way over there? That's 50 miles," going to get Varya to give him the signal that he needs from her? Yet, that is exactly what the actor must accomplish.

An open scene using the same premise and characterizations of the actual scene is an excellent way to remember that the actor can never play the lines. He or she needs to bend the lines to serve their purpose in the scene. Use the same floor plan, the same physical behavior: Varya entering and examining the luggage, and Lopakhin in traveling clothes ready to depart.

Give the actors playing Varya and Lopakhin this open scene with the same scene objectives: get him to ask for your hand vs. get her to prove to you that she wants to be asked. Make the words of the open scene work on the other person to accomplish your purpose.

Why Stop Now

LOPAKHIN:	Should we be doing this?
VARYA:	Why stop now?
LOPAKHIN:	I don't know about this.
VARYA:	Are you having second thoughts?
LOPAKHIN:	Perhaps.
VARYA:	I don't want to force you.
LOPAKHIN:	I didn't mean that.
VARYA:	We have to be in this together.
LOPAKHIN:	I know.
VARYA:	Good.
LOPAKHIN:	I'm just not certain.
VARYA:	Well, it's up to you.
LOPAKHIN:	That's not fair.
VARYA:	Oh, but it is.
LOPAKHIN:	How is that fair?

72 *Problem Solving With Open Scenes*

VARYA: You said you wanted to stop.
LOPAKHIN: No, I didn't. I said I wasn't sure.
VARYA: Well, you have to make up your mind.
LOPAKHIN: Why do I have to decide?
VARYA: You have to decide for yourself.

Using Synonymous Language

This open scene isn't any more or less about a marriage proposal than the scene from *The Cherry Orchard*. It is the job of the actors to transform the word symbols into instruments of change. Making "You said you wanted to stop," into a way of getting him to ask you to marry him is no different than saying, "anyway, the thermometer is broken," for the same purpose. Use the open scene to practice making the word symbols serve your need. Then take that same energy and use it in the scene from the play. It is often helpful to use synonymous language to give you the energy behind the line that activates the word symbols:

VARYA: Are you having second thoughts? (**It's GOOD that you aren't sure.**)
LOPAKHIN: Perhaps. (**But, are YOU sure?**)
VARYA: I don't want to force you. (**I'll be ready, only when YOU are ready.**)
LOPAKHIN: I didn't mean that. (**I want you to tell me you are ready.**)
VARYA: We have to be in this together. (**I will never, ever, push you into anything.**)
LOPAKHIN: I know. (**Is this what you want?**)
VARYA: Good. (**I'm ready, ask me.**)

The exercise is useful because it makes the actor communicate "I'll be ready, only when YOU are ready," but using the word symbols, "I don't want to force you." The communication is positive and affirming of Lopakhin in that she conveys that she respects his sense of timing and will wait for him, even though the word symbols, "I don't want to force you," seems on the face of it to be defensive or even frustrated. When the actors have played the open scene several times, try then applying this energy to the actual scene. Just as they did with the open scene, force the lines that Chekov has provided to communicate what will win the scene for each actor. Give Lopakhin the signal you think he wants and get Varya to say the words you need to hear.

VARYA: (examines the luggage takes her time) That's funny, I can't find them. (**I don't WANT to find them.**)

LOPAKHIN:	What are you looking for? (**Are you hinting that you don't want to go?**)
VARYA:	I packed them myself, and now I don't remember where. (**Ask me WHY, I can't remember I could use your help.**)

Pause.

LOPAKHIN:	What (**have you suddenly become helpless?**) ... ah ... where are you off to, Varya? (**I want you to TELL ME you are ready.**)
VARYA:	Me? I am going to work for the Ragulins. (**Unless you stop me.**) I talked about it to them already; they need a housekeeper. (**I am sturdier than you believe and will make a good wife.**) And, look after things, you know ... (**TELL me not to go.**)
LOPAKHIN:	All the way over there? ... (**You've decided to leave me?**) That's 50 miles away. (**Is this what you really WANT?**) Well, looks like this is the end of things around here. . . (**Give me a sign that you want me.**)

The result of both actors trying desperately to communicate with each other and urgently attempting to make the scene about an offered and accepted proposal will make it all the more heart breaking. The use of an open scene will be of immeasurable value in giving the actors another reminder not to play the lines, which is especially significant in this scene where Chekhov provides virtually nothing (on the surface) for the actor to play.

WHAT IF WE CHANGED VARYA'S POINT OF VIEW? Imagine this situation: Varya is terrified that Lopakhin will see her as too eager and that will drive him away, so she appeals to his strength and gentlemanly nature by making him see that she is afraid and helpless without his strength. Once he sees this, he will "play the man" and sweep her away. This, of course, has the unintended result of accomplishing the opposite by putting him off, because he is attracted to her personal and family strength, which he admires and envies. By trying to be what she thinks he wants, she makes it impossible for him to ask the question.

Acting Challenges Posed in the Play, *Doubt*

This brilliant, Pulitzer Prize winning play by John Patrick Shanley takes place at St. Nicholas Catholic church and school in the Bronx. Sister

Aloysius Beauvier is the principal of the school and is in her early 60s. Father Brendan Flynn, about 35, is the priest assigned to serve the church and school. Throughout the course of the play, Sister Aloysius becomes convinced that Father Flynn is having an illicit relationship with one of the young male students in the school. Near the end of the play, Sister Aloysius confronts Father Flynn, demanding that he confess and resign his position.

Problem: Not Playing the End of the Scene at the Beginning

Before you proceed in this chapter, read the last half of Scene 8 of *Doubt, A Parable* by John Patrick Shanley, beginning following Mrs. Muller's exit near the bottom of page 45 in the Dramatists Play Service, Inc., acting edition. This is available online in several places, including:

www.cressonlake.com/wp-content/uploads/2016/06/Doubt-Shanley.pdf

Problem to Solve: The challenge in this scene is that both actors know the story ends with Father Flynn succumbing to her threats. The scene culminates with Father Flynn agreeing to request a transfer from the parish and take a leave of absence until the bishop grants the request. If the actors play the story, then the scene becomes about Aloysius attacking the priest and Father Flynn defending himself and eventually giving in to her demands. The authors have seen several productions of this play, and each time the end of the scene is written all over the face of the actor playing Father Flynn. The look on his face says, "I'm going to lose this scene because I really did it, but I will defend myself for about three pages or so." She attacks, and he becomes angry and defensive and both actors play the story.

It is difficult to blame the actors for playing the story, because it is really challenging to make the words work for the Father Flynn character. In many ways the scene and the story are stacked against him. Lines like: "You are attempting to destroy my reputation," "Why do you suspect me, what have I done?", "You have not the slightest proof of anything!", and "You have no right to go rummaging through my past." all seem to suggest that Flynn is intimidated and on the defensive because he knows he is guilty. Equally daunting are Sister Aloysius' lines such as "What are you doing in this school?", "What are you doing in the priesthood?", and "You will tell me what you've done," which seem to indicate that Aloysius knows that he is guilty before the scene starts. But the scene is about getting him to admit what she suspects, not what she knows. It is very easy for the scene to deteriorate into a confrontation between a man who is lying and defending

himself and a woman who is denouncing him because she is absolutely sure of his guilt.

This, of course, results in a scene completely devoid of conflict and dramatic interest. What is the point of dramatizing a confrontation with a predetermined outcome? A scene can only work if there is dramatic action (i.e., conflict) in which both characters are trying to change the behavior of the other. Despite how the lines might read, this scene cannot be a scene where Sister Aloysius confronts Flynn with the truth and he defends himself. If Sister Aloysius was absolutely certain of the truth what would be the purpose of confronting Father Flynn? She would simply go directly to the bishop with her evidence and demand that he act. But, in this situation, Sister Aloysius has strong suspicions for which she needs confirmation (or contradiction) from Flynn himself. She needs her doubts to be resolved because she isn't absolutely certain she is right, or at least that she has any real proof. She confronts him to force the truth out of him, whether that results in an admission and begging for forgiveness, whether that is proving to her that she is wrong (however unlikely in her opinion), or whether something is entirely unforeseen. Regardless, she WILL get him to admit the truth. This is a woman who very much *believes* she is right but still wants proof even if that proof might not be permissible in a court. She must know, and it is her relentless quest for the truth that keeps her from being reduced to a mindless zealot the audience can keep at arm's length. All this is further exacerbated by the fact that she is relatively powerless in this male-dominated, hierarchical Catholic culture with strict rules that preclude her from doing exactly what she is now doing, which is to say that she cannot rely on the bishop for support. She is tenacious precisely because she is the only person who can solve this problem. She is well aware that, in effect, she has launched on a one-person encyclical.

What is the scene about for Father Flynn? The play does not reveal whether Flynn actually does have an improper relationship with the boy, and perhaps Flynn might never be able to face the truth of a sexual relationship with the boy in any event. Regardless, he enters the scene with what Shanley calls, "a controlled fury." For Flynn, the scene is about the vendetta that Sister Aloysius has launched against him. Her personal life frustrations with men and possibly even her jealousy over Flynn's popularity with the boys are driving her to attempt to destroy the life and career of a good man and priest. As Father Flynn enters the scene, he is determined to flip the tables on Aloysius and expose the truth that she is inventing this entire scenario to serve her personal malice against him. The scene for Father Flynn is getting Aloysius to admit what she is doing and apologize to him. Therefore, they both have the identical objective in the scene: she is getting him to admit the truth, and he is getting her to admit the truth. Further, he is fueled by his

belief in "the system" and is outraged by her disregard for the rules of the path they have both chosen.

It is VERY challenging, especially for the Father Flynn actor to make the lines serve this purpose. For Father Flynn, he needs to put her on the defensive and hold the mirror of truth up to her so that she can see the evil she is doing. He must make her see that her suspicions are leading her to abandon the oaths she has taken, that in effect, her suspicions are making her a bad nun who is in opposition to the Church. While not predetermined by the text, it might help the actor playing Flynn to be affected by the unfairness of attacking him for something that he himself has struggled against for so long and so successfully. It is not right to be attacked for the "sins of the heart" that afflict him, but which he has NEVER acted on. Likewise, Sister Aloysius cannot simply proclaim his guilt over and over again. Instead, she has to confront him with her suspicions so that she can read his eyes and his heart for the truth even if this leads her into action that she would never condone even in herself, for example, lying to him about what she has "learned." This action comes at a great personal cost to her, so she cannot long succumb to the exhilaration of "Gotcha." A wonderful way to practice activating the words to serve this purpose is to use an open scene.

Open Scene Solution

Keep the same premise and scene objectives in the same room with the same characters. Using the open scene, *How Can You?* works to make the word symbols bend to your purpose. For Flynn, get her to admit that she has invented this entire situation and apologize to you. For Aloysius, get him to admit what he is done and ask for forgiveness (because that will prove to yourself that he has actually done it).

How Can You?

FLYNN: How can you support that?
SISTER: I don't support it.
FLYNN: You're not against it.
SISTER: Yes, I am.
FLYNN: No, you're not.
SISTER: Don't tell me what I'm for and against.
FLYNN: I'm just saying what I see.
SISTER: Really?
FLYNN: Absolutely. I call it as I see it.
SISTER: And you think I'm for that.

Problem Solving With Open Scenes 77

FLYNN: If you're not against it, you're for it.
SISTER: I am against it. You don't see me do it, do you?
FLYNN: I don't see you condemn it.
SISTER: And you do?
FLYNN: I'm doing it right now.
SISTER: But I'm not doing it.
FLYNN: You might as well be.
SISTER: I think you have to go now.
FLYNN: Bigot.
SISTER: Idiot.

The great value in using this open scene is that it allows the Father Flynn character to put Sister Aloysius on the defensive. What does this energy feel like? Once the Flynn actor is freed from the words of the scene, he can develop the point of view that Aloysius is the one who is lying and concealing and performed the greater sins and needs to apologize and ask forgiveness. He must get her to admit that she has reduced herself to underhanded tactics and no longer has the high moral ground in this relationship. This is critically important for the scene from the play to work. Rather than playing the one who is wrong and is on the defensive because he knows he did it, the Flynn actor can enter the scene and expose the malice and dishonesty of the Aloysius character. The audience will be able to recognize that this is how denial works. The person who actually does the deed (in this case with the boy, whether or not the act has in fact been consummated) is psychologically unable to admit the truth, and they project their guilt by blaming someone else (in this case, Sister Aloysius).

The difficult challenge for the Flynn actor is that he must be convinced that he will expose her mendacity and her unsuitability for her vocation so that she will crumble when confronted with the truth. He needs to play the one who is going to win the scene, and the actor should write down in his script the exact line she will say when she breaks down and admits the truth. Look at the line in the open scene "I'm just saying what I see." Empower those words to hold the mirror up to her as if the line were, "look at the truth written all over your face, Sister." Or, with the line, "If you're not against it, you're for it," energize those word symbols to pierce her armor as if the line were "You are accusing me because you can't face the truth about yourself." Now, use that same energy with the line from the scene, "You know what I haven't understood through all this? Why do you suspect me? What have I <u>done</u>? What proof do you have that I have actually done anything?" Rather than playing these lines as if they were questions, the Flynn actor uses the energy from the open scenes to make them expose

the truth of what Sister Aloysius is doing. Play the lines as if they were "Look at yourself in the mirror, Sister, you are accusing me of doing what YOU are doing!!"

The purpose of using an open scene to help with the encounter from *Doubt* is to enhance the ability of the actors to play the dramatic action in the scene. As we said earlier, the scene cannot work unless both characters are trying to change each other. They both are determined to expose the truth that the other is hiding, but that is less obvious in the case of Father Flynn because the line seems to suggest he is on the defensive. To help the Flynn actor play his side of the bargain in the scene by putting her on the defensive, the open scene provides great practice in developing that energy. Then take the energy of the one who will WIN the scene and apply it to the scene from *Doubt*. The same energy that the actor uses when he says, "How can you support that?" will vitalize the line from the play, "You are attempting to destroy my reputation." In both cases, the Flynn actor plays the energy of the stronger character in the scene; the one who will win the scene. "You are attempting to destroy my reputation" are now the perfect words that Father Flynn needs to get Sister Aloysius to admit that it is she who must leave the school.

By way of making sure each actor in the scene is truly playing their dramatic action, reverse the dialogue.

SISTER: How can you support that?
FLYNN: I don't support it.
SISTER: You're not against it.
FLYNN: Yes, I am.
SISTER: No, you're not.
FLYNN: Don't tell me what I'm for and against.
SISTER: I'm just saying what I see.
FLYNN: Really?
SISTER: Absolutely. I call it as I see it.
FLYNN: And you think I'm for that.
SISTER: If you're not against it, you're for it.
FLYNN: I am against it. You don't see me do it, do you?
SISTER: I don't see you condemn it.
FLYNN: And you do?
SISTER: I'm doing it right now.
FLYNN: But I'm not doing it.
SISTER: You might as well be.
FLYNN: I think you have to go now.
SISTER: Bigot.
FLYNN: Idiot.

The Big Challenge in *Proof*

Before you proceed in this chapter, read the last half of Act II, Scene 5 of *Proof* by David Auburn until Hal enters. This is available online in several places, including:

> https://my-ebooks.club/-/reader-roman/#/flow=PTqNVl+cdn.af5.club/s1=/s2=/s3=/s4=reader-roman/s5=/cid=hhhek5v2zs/source_id=6566/q=Proof%3A+A+Play.pdf/

Another Pulitzer Prize winning play, David Auburn's *Proof* is the story of two sisters who are dealing with the death of their famous mathematician father. The younger sister, Catherine lives alone in the house she once shared with her dead, mathematical genius father, who gradually succumbed to mental illness. She is exceptionally intelligent but struggles with lack of ambition and a poor sense of her own identity. She is shy, awkward, and very sensitive and has had little social interaction for almost nine years. She resorts to sarcasm to cover her fear that she has inherited her father's illness. She knows she has acquired his mathematical mind but doesn't want it to make her abnormal and lonely.

Claire is Catherine's older, more successful, and conventional sister. She is a dominant, take-charge personality who thinks Catherine is risking her emotional health by staying in the house and instead should come live with her husband and her in New York. She is afraid of the mental illness of her father and worries that her sister is on the same track. She struggles with guilt that she has been in New York instead of helping with her father's decline and that Catherine blames her for abandoning the family.

In the first part of the scene, Claire introduces the idea that Catherine should move to New York to be near Claire. She argues that now that their father is dead there is no longer any reason for Catherine to stay in the old house and that she can help Catherine choose a cute New York apartment. Catherine counters that she wants to take time to assess her future and the house is a place of stability and connection for her to decide what she wants to do. Underlying and intensifying the discussion of the house are the issues of whether Catherine has inherited her father's mental illness and the guilt Claire feels about her absorption in her New York life that left Catherine alone to deal with their father.

What to Do When the Scene Is Stacked Against One Character

Problem to Solve: The challenge in this scene takes place when Claire tells Catherine that she cannot stay in the house because Claire (who paid off the mortgage) is going to sell the house. Now, suddenly the entire scene has

changed because Catherine is no longer able to just decline Claire's invitation and stay in the house. Catherine must either knuckle under to her Sister's will and agree to move to New York or somehow get Claire to change her mind and promise not to sell the house. For Catherine, going to New York would in fact be a self-confirmation that she needs professional help because she has inherited her father's mental illness. She must conjure all her powers to find a way to make Claire reverse her decision to sell the house.

Open Scene Solution: The challenge for Claire in this part of the scene is that the language (and the story) can easily trap her into playing "angry and defensive." But even though she is angry and defensive, operating with that energy will be counterproductive because it will simply convince Claire even more strongly that Catherine is imbalanced and needs to be under professional care in New York. The best and only thing Catherine can do is to take command of the situation and make her sister feel shame and embarrassment for what she is doing to her by selling the house. Catherine cannot play her own problem of not wanting to go to New York, rather she must fix her sister's problem of being clueless to the damage she is doing to Catherine, to the memory of their father, and to herself and her marriage. In other words, Catherine must play the stronger and wiser of the two in the scene and create a change in Claire's consciousness that results in her promising not to sell the house.

This takes practice because it requires Catherine to take lines like "Where am I supposed to live?", "I can't believe this," and "Don't lie to me, Claire, I'm smarter than you," and bend them to serve her purpose of getting Claire to change her mind. "I can't believe this," is a line that almost begs the actor to play shock and anger, but although Catherine is undoubtedly shocked and angry, playing this energy is not going to get Claire to change. What if Catherine played the line with the energy of, "Claire, you are SO much better than this" The line would still contain the word symbols, "I can't believe this," but the energy would be more like a parent (Catherine) calling her child (Claire) to a better behavior.

An excellent way of giving Catherine the feeling of being the stronger and more persuasive of the two in the scene is to use the open scene, *You Shouldn't Be Here*. Keep everything about the scene just as it is but use the words of the open scene to get the Catherine actress in touch with the energy that can both shame and inspire Claire to do the right thing. In this open scene, let Catherine be the one who is putting Claire under the microscope and pushing her to admit that she "shouldn't be here."

You Shouldn't Be Here

CATHERINE: You shouldn't be here.
CLAIRE: Says who?

CATHERINE:	You know you shouldn't.
CLAIRE:	Well, here I am.
CATHERINE:	They won't like it.
CLAIRE:	They can go pound sand.
CATHERINE:	You can't be here.
CLAIRE:	And yet here I am.
CATHERINE:	There'll be hell to pay.
CLAIRE:	There often is.
CATHERINE:	Don't be like that.
CLAIRE:	Where else would I be?
CATHERINE:	What am I going to do with you?
CLAIRE:	Whatever you like, I imagine.
CATHERINE:	Oh, my.
CLAIRE:	Oh, yeah.
CATHERINE:	You shouldn't have come.
CLAIRE:	So you said.
CATHERINE:	You can't be here.
CLAIRE:	I'm not going anywhere.
CATHERINE:	You have to.
CLAIRE:	Not gonna happen.

What working on this open scene does is empower Catherine in a way that is more difficult to do with the words of the scripted scene from *Proof*. Also, the actress must not simply accept that Claire said she is selling the house and that ends any discussion about it. When Catherine puts it clearly to Claire, "What am I going to do with you?" it is the energy of an older sister shaming a younger one for something she has done. This is exactly the energy that is needed in the scripted scene because Catherine must be pushing Claire to give up the idea of selling the house just as hard as Claire is pushing Catherine to admit she really wants to go to New York. In other words, a scene needs conflict in order for its story to be told, and the words and story of the scene from *Proof* are stacked against Catherine and require that the actress playing the role understands how to play her side of the bargain in the scene. That is why using an open scene is such an excellent way of helping her do just that. It is essential that the Catherine actress offers real ways that would allow Claire to change her intention of selling the house. When confronted with news that we don't want to hear, we often are desperate to hang on to any viable alternative. In this case, that might mean, "Okay, you agreed to sell it, but if the papers haven't yet been signed and the money hasn't changed hands yet, it's still not too late. And how could all of that have happened so quickly anyway?"

Once again, to fully understand the energy each brings to bear on the dramatic action, it might be useful to exchange dialogue without altering what each wants from the other.

CLAIRE:	You shouldn't be here.
CATHERINE:	Says who?
CLAIRE:	You know you shouldn't.
CATHERINE:	Well, here I am.
CLAIRE:	They won't like it.
CATHERINE:	They can go pound sand.
CLAIRE:	You can't be here.
CATHERINE:	And yet here I am.
CLAIRE:	There'll be hell to pay.
CATHERINE:	There often is.
CLAIRE:	Don't be like that.
CATHERINE:	Where else would I be?
CLAIRE:	What am I going to do with you?
CATHERINE:	Whatever you like, I imagine.
CLAIRE:	Oh, my.
CATHERINE:	Oh, yeah.
CLAIRE:	You shouldn't have come.
CATHERINE:	So you said.
CLAIRE:	You can't be here.
CATHERINE:	I'm not going anywhere.
CLAIRE:	You have to.
CATHERINE:	Not gonna happen.

The Big Challenge of *Angels in America*

Before you proceed in this chapter, read Scene 8 of *Angels in America: Part One, Millennium Approaches* by Tony Kushner until Louis enters. This is available online in several places, including:

www.academia.edu/34774565

Yet another Pulitzer Prize winner, this two-part epic drama is a complex and highly metaphorical treatment of homosexuality and the AIDS crisis in the United States during the 1980s. The plot winds several stories together, and one of them concerns a married couple, Joe and Harper Pitt. Joe and Harper are both Mormons and live in New York City where Joe is a Republican clerk for a Federal judge. Offered a job in Washington, D.C., Joe hesitates to accept because of his deteriorating relationship with Harper.

Underlying their marriage is Joe's neglect of Harper due to his increasing realization that he is gay and Harper's escape into drugs and fantasy.

The story of the scene is a confrontation between Joe and his wife, Harper. He has, not for the first time, returned to their apartment very late, and Harper is at the breaking point. Terrified that he is lying to her about where he goes, she purposely burns his dinner and demands he tells her the truth. Struggling to hide his homosexuality and not succumb to what he believes is a sin he tries to evade her questions about his orientation by proclaiming his decency as a person, but Harper will no longer allow him to evade the truth and dares him to admit he is gay. When he continues to deny the obvious, she claims to be pregnant and taunts him when he asks whether she is being honest. The scene ends with the bitter realization that both are hiding the truth.

One Character Wants the Scene, and the Other Wants to Leave the Room

Problem to Solve: As the scene begins, Harper has been waiting for hours as her anger builds. She will not allow anything to prevent her from learning the truth about her husband and will do ANYTHING to get him to drop his artifice and be honest with her. Joe, on the other hand, seems committed to avoiding trouble with Harper and going to bed. In other words, the story of the scene is that Harper is demanding to have a confrontation and Joe is keen not to have anything of the sort. Since we can assume that a playwright is not going to craft a scene in which one character wants the scene and the other just wants to leave the room, the actors (especially the Joe actor) have to fight the way the lines and the story are stacked against them.

Unless both characters are equally invested in the scene, there can be no dramatic action, and yet look at the lines that confront the Joe actor. Joe knows as soon as Harper tells him that she burned the dinner that a showdown of some sort is going to take place. Yet, he gives her terse, one-line, "nonanswers" instead of the response she wants. He knows full well what she wants from him, yet he answers her about where he has been with, "Out," "Just out, thinking," "I had a lot to think about," and "Sorry." He continues his nonanswers by trying to change the subject to how many pills she has taken and prattles on about his job instead of confronting what he knows she means. Finally, he tries to avoid the entire encounter altogether by leaving the room saying, "I'm tired, I'm going to bed," and "This is crazy, I'm not . . ." Finally, in desperation she asks him (rhetorically), "Are you a homo?" At this point in the scene, both characters at least engage the central issue of the confrontation despite the fact that there is no resolution.

The problem then is how to play a scene in which one character seems to want to avoid the scene altogether? How does the Joe actor fight the

tendency of the text to make him play, "I don't want to have this scene, I just want to go to bed." Certainly, that is what the lines suggest, so to return to the lesson of the two people in the restaurant in the opening chapter, the Joe actor asks himself what he is trying to get Harper to do in the scene. Although he walks in the door wanting to avoid any confrontation and go to bed, it is obvious within the first few lines that this will be impossible. He also cannot play a negative energy ("I will not admit my homosexuality at all costs."). He must defuse this toxic situation. The Joe actor needs to ask himself: what energy can I play to fix Harper's problem in the scene? From Joe's perspective, Harper's problem is that when she is drugged, she makes everything about herself and wildly exaggerates any situation.

Because Joe dreads a conversation about his sexuality, his only hope is to focus the scene on Harper and get her to reinvest in saving their marriage. He needs to take her accusative energy and redirect it into challenging her to work *with him* to commit themselves to what is "decent, correct, and good." Joe must get Harper to celebrate the fact that he is an honorable man who will fight to keep their marriage alive. He needs Harper to promise him that this is enough for her and that she will fight alongside him to save their marriage. Because he has so internalized the teaching of his church that homosexuality is a sin, he actually believes that this is his personal conviction. He therefore hangs on to the idea that if he doesn't act on his impulses he will still be a good person in God's eyes and in the eyes of the people in his world. He NEEDS Harper to help him in his quest, because only Harper can help . . . if only she will get it together. Now the conflict in the scene is clear: Harper wants the truth and a promise that he won't abandon her; Joe wants Harper to focus on the marriage and promise that she will accept him as he is.

Admittedly, this is extremely difficult for the Joe actor because the lines almost beg him to play his problem instead of fixing Harper's problem. But, if the Joe actor comes into the scene playing a dishonest character who knows the truth but tries hard to deceive his wife, then the scene becomes story playing and the actor is playing the analytical assessment of his own character. Instead, because he cannot (yet) face the truth of his sexuality, he needs to be effective and persuasive in making the scene about telling the truth about something else; namely, that they are both good and decent people and they can work it out together.

The Open Scene Solution: To help Joe in capturing this energy in the scene, keep the exact same objectives but transfer them to this open scene, *Where Is It?*

Where Is It?

HARPER: Where is it?
JOE: Where is what?

HARPER:	I said, where is it?
JOE:	I heard what you said.
HARPER:	Then where is it?
JOE:	You don't even know what you're looking for.
HARPER:	Is that all you've got to say?
JOE:	Is that all you've got to ask?
HARPER:	Are you going to tell me where the fuck it is, or not?
JOE:	Did you hear what you just said?
HARPER:	This is about YOUR problem, not mine.
JOE:	This is about . . .
HARPER:	WHERE IS IT?
JOE:	Why do you keep asking the same thing?
HARPER:	Because you know where it is, don't you?
JOE:	This is not you. You are better than this.
HARPER:	You know where it is, just tell me.
JOE:	I have no idea what you are looking for.
HARPER:	Or, maybe you don't want me to find it.
JOE:	Or, maybe I want you to find it yourself.
HARPER:	Find what?
JOE:	Yes, that is just it. Find what?
HARPER:	Well, maybe I already found it.
JOE:	Well, then maybe it doesn't matter.
HARPER:	Well, then, maybe you don't matter.
JOE:	Maybe not. But you do. You do.

In this scene, both Joe and Harper are trying to get the other to focus on the truth THEY want them to confront. For Joe, get Harper to see herself as better than her fears. "Did you hear what you just said?" and "This is not you, you are better than this," are both opportunities to break through Harper's fear and hostility by calling to her better, healthier, more mature self. If Joe can play that same energy when he says in the scene, "I know who you are," it becomes a vote of confidence in her rather than a slight. In the open scene, make the line "or maybe I want you to find it yourself" allow her to feel that your love and decency are stronger than her fear and suspicion. Take that same energy and make her see the love Joe feels when he says, "I am a very good man who has worked very hard to become good." At the end of the open scene, use the line "but you do. You Do" to penetrate her heart with the realization that she matters deeply to Joe. Then take that same energy and make the line "You want to destroy me but I am not going to let you do that" accomplish the same thing. Don't let the word symbols manipulate Joe into playing some sort of defensive, threatening, energy. Instead, manipulate the word symbols to serve Joe's purpose. Give them the emotional meaning of "I will never,

ever, give up on you. We both have a purpose, and right now, that purpose is helping each other."

Ending Where We Started: Make the Words in the Script Serve Your Purpose

As we have said from the first chapter of this book, printed scripts, essential as they are and brilliant as they may be, can imprison the actor who takes their cues from the printed page and "acts the script" as if it were a recipe to be followed steadfastly. The lesson learned over and over again is that lines in a script are not indications of what the actor should play. Instead, they are opportunities for the actor to make something happen to the other person (or other people) in a scene consistent with their objective. As we have seen, this tendency to let the words play the actor is particularly deadly in auditioning for commercial and TV/Film roles. Because open scenes are not connected to a story, the actor is free to do what they should always do in any scene: bend the words to serve their purpose.

If there is one idea that we hope sticks in your memories from using this book it would be that the actor can never be the one who tells the story. Playing the story is the root cause of most every acting problem. Just as a baseball player cannot possibly know the outcome of the game in the second inning or a mother holding her baby can never know what life will bring to the child, the character in a play or a film can never know in advance what will happen in a particular scene. The use of open scenes is a remarkably effective way of teaching an actor how to play action and objective (need) which keeps them in the moment, instead of playing the story of the script. Teacher, director, and student can return to open scenes at any time when the power of the story begins to overwhelm the actor. The payoff will be that the characters in the play or film will behave truthfully in the imaginary premise of the play, completely unaware of what is going to happen. The audience, who after all pays the money for their tickets, will be the lucky ones who get to diagnose the characters, figure out the story, and react with emotion and empathy. The actors have done their jobs and the play is well served.

Open Scenes

Are You Kidding Me?

A: Whoa!
B: What?
A: Are You Kidding Me?
B: Sorry.

Stop

A: Stop.
B: I beg your pardon.
A: Don't you dare.
B: Go fuck yourself.

That's How I See It?

A: Anyway, that's how I see it.
B: I couldn't agree more.
A: Really?
B: Absolutely.

Why Would You Do That?

A: Why would you do that?
B: Seemed like a good idea at the time.
A: That's it?
B: That's all I've got.

Stop, Quit, Don't

A: Stop.
B: Quit.
A: Don't.
B: Stop.
A: Quit.
B: Don't.

Come On

A: Come on.
B: What?
A: Come on.
B: Where are we going?
A: Come on.
B: Wait.
A: Let's go.

Oh, No

A: Oh, no.
B: What?
A: Are you kidding me?
B: What?
A: Unbelievable.
B: What?
A: Crap.
B: WHAT!?!

Hold On One Second

A: Hold on one second, please.
B: Really?
A: Just one moment, please.
B: You know I've been waiting, right?
A: Yes, and I do apologize.
B: Oh, man.

A: I do apologize.
B: Don't keep saying that. Just do what you need to do.

You First

A: Ready?
B: Sure.
A: You sure?
B: Sure. I'm sure.
A: Then let's go.
B: I'm ready.
A: What are you waiting for?
B: You first.
A: After you.
B: No, no, no. It was your idea.
A: Okay, here goes nothing.
B: Go already.

This One's Yours

A: Here.
B: What is this?
A: Try it.
B: What is it?
A: It's for you.
B: Yeah, but what is it?
A: It's what I've been talking about all week.
B: Oh, right.
A: This one's yours.
B: Thanks.

What the Hell Is That Thing?

A: What the Hell Is That Thing?
B: I have no idea.
A: Is it a . . .
B: I'm not sure.

A: What do you think?
B: It could be.
A: Think so?
B: Probably. I don't know.
A: If it is . . .
B: I know.

Is This It?

A: Is this it?
B: I think it is.
A: What can I do?
B: Do you have super powers I don't know about?
A: I want to help.
B: I know.
A: What can I do?
B: Just relax.
A: But—
B: Please.

I Forgot

A: I forgot.
B: Forgot what?
A: How am I supposed to answer that?
B: It's a trick to prod your memory.
A: Well, it didn't work.
B: Sort of catching you by surprise.
A: That's dumb.
B: Sorry.
A: Oh, I just remembered.
B: You're welcome.

Exactly

A: Okay. . .
B: Yep.

A: Wow...
B: This is...
A: Exactly.
B: It's...
A: Exactly.
B: Exactly.
A: I just...
B: Exactly.

Are We Done?

A: So, are we done?
B: Oh, yeah.
A: Completely?
B: We're done.
A: Okay.
B: Completely. Thoroughly. Irrevocably.
A: So that's clear.
B: I don't know how to be clearer.
A: All right then.
B: Indeed.

You Always Say That

A: You always say that.
B: Do I?
A: You do.
B: Huh.
A: I hope you know you do.
B: I guess.
A: You guess?
B: Okay.
A: Okay?
B: I guess I do.
A: And...
B: I'll have to give that some thought.
A: You do that.

B: I will.
A: Okay.
B: Okay.

Where Is It?

A: Where is it?
B: What?
A: You know. Tell me where it is.
B: It's here, somewhere.
A: A clue?
B: No clue.
A: It's not here, is it?
B: It might be.
A: What did you do with it?
B: Do with what?
A: Is it on you?
B: Seek and ye shall find.

How Long Have You Been Here?

A: How long have you been here?
B: Not long. What kept you?
A: Nothing, I'm just running late.
B: You OK?
A: Sure. Why are you looking at me that way?
B: What way?
A: That way. Look, if we're going we'd better go.
B: Do you still want to?
A: I'm here.
B: But do you want to?
A: Why? Have you changed your mind?
B: Maybe.

What Is This?

A: What is this?
B: What?

A: This. Is it yours?
B: No. Is it yours?
A: Why would I be asking if it's yours if it was mine?
B: Were.
A: What?
B: Conditional. Were mine, not was mine.
A: What are you talking about?
B: Why would I be asking if it were mine?
A: I was asking—
B: If it were mine? Yes.

You're Late Again

A: You're late again.
B: I'm sorry.
A: You're sorry.
B: What are you doing?
A: Leaving.
B: But we're supposed to—
A: Not anymore.
B: What?
A: I replaced you.
B: You replaced me. Are you kidding me?
A: Yes.
B: I knew it.
A: No. I'm not kidding.
B: What do you want from me? Name it. Anything.
A: OK

Feeling Lucky?

A: Feeling lucky?
B: Why?
A: Are You?
B: What about?
A: Just wondering if you want to give it a shot.
B: Do you?

A: Maybe. What do you think?
B: I don't know.
A: So you don't feel lucky.
B: Does luck really have that much to do with it?
A: Couldn't hurt.
B: I guess.
A: So, what do you think?
B: Let's do it.

That Sucked

A: That sucked.
B: Agreed.
A: Let's try it again.
B: I don't see the point.
A: We can't leave it that way.
B: How will we make it better?
A: Maybe . . . you can try harder?
B: You're saying it sucks because of me?
A: No. I need to try harder, too.
B: We shouldn't have to try. We're trying too hard. That's why it sucked.
A: So, maybe . . . we just don't try?
B: Well . . . yes. Let's just do it.
A: OK, we'll just . . . do it.

You Shouldn't Have Done That

A: Uh-oh.
B: What?
A: You shouldn't have done that.
B: You think?
A: Just sayin'.
B: Well, thanks for nothing.
A: Hey.
B: I mean a lot of good that does me now.
A: Well, I didn't know you were going to do that.

B: What did you think I was doing?
A: Not that.
B: Just be quiet and let me think.

Remember That Thing I Said Earlier?

A: Remember that thing I said earlier?
B: Sure.
A: And you laughed.
B: Yeah.
A: You didn't hear me, did you?
B: Not really. No.
A: But you laughed.
B: Busted.
A: Busted.
B: I didn't want to be rude.
A: So you were condescending instead.
B: How am I supposed to handle that?
A: Pay attention in the first place?
B: Really?

That Was Weird

A: That was weird.
B: Wasn't it?
A: Oh, yeah.
B: Weird.
A: Weird.
B: So . . .
A: Right.
B: It was . . .
A: Weird.
B: (Laughs.)
A: What do we do now?
B: Well, we could do it again.
A: I like that.

B: You game?
A: Oh, yeah.
B: All right.

Why Are We Here?

A: Remind me.
B: What?
A: Why are we here?
B: To get the—
A: Why?
B: It's why we came.
A: But I don't want it.
B: You should have said.
A: I did.
B: Did you?
A: Don't start that. You know I did.
B: Well, here we are.
A: Not me. I'm out of here.
B: Don't you leave me here alone?
A: We shouldn't be here.
B: Well, we're here, so let's get it and get out of here.

Why Stop Now?

A: Should we be doing this?
B: Why stop now?
A: I don't know about this.
B: Are you getting cold feet?
A: Maybe.
B: I don't want to force you.
A: I didn't mean that.
B: We have to be in this together.
A: I know.
B: Okay.
A: I'm just not sure.

B: Well, it's your call.
A: That's not fair.
B: Sure it is.
A: How is that fair?
B: You said you wanted to stop.
A: No, I didn't. I said I wasn't sure.
B: Well you have to make up your mind.
A: Why do I have to decide?
B: You have to decide for yourself.

Okay

A: Okay?
B: Sure.
A: You sure?
B: Yeah.
A: Really?
B: Really.
A: Okay.
B: Okay.
A: I'm not really hearing "okay."
B: No.
A: No?
B: No. I mean, no, it's okay.
A: Okay.
B: Okay.
A: If you're sure.
B: I'm sure.
A: Yeah?
B: Yes.
A: Okay.
B: Okay.
A: Okay.
B: Enough.

You Ready?

A: You ready?
B: Not really.
A: Me either.
B: Okay.
A: I mean I'd be happy to pass.
B: Yeah?
A: If it's all the same to you.
B: Me?
A: Yeah.
B: I thought you wanted to.
A: I did.
B: Me too.
A: But I think I've changed my mind.
B: You sure?
A: Pretty much.
B: Come on.
A: No, I mean I'm over it.
B: Good. Me too.
A: So?
B: Let's get out of here.

A TO Z

A: "The whole enchilada," four letters
B: Toto?
A: Like the dog?
B: Like *en toto*.
A: I don't think so.
B: *Tutti*?
A: Four letters.
B: *Tops*?
A: The second letter is *T*.
B: What else comes down?
A: This comes down.

B: Across then.
A: *On Fire* six letters. The fifth letter is the last letter.
B: *Ablaze.*
A: Blank, *T*, blank, *Z*.
B: *A, T, O, Z.*
A: *ATOZ?*
B: *A to Z.*
A: Aaaaarggghhhh.

Blue Bayou

A: I AM ON FIRE!
B: Bringing the heat.
A: Is that a—?
B: Baseball thing? Yeah.
A: Of course.
B: Sorry.
A: Meaning?
B: The high, hard one. The cheese. The Ronstadt.
A: Like Linda?
B: Yeah.
A: Why?
B: When you blow the fastball by the batter, *Blue Bayou.*
A: Got it. So, why isn't it "the Orbison"?
B: Why?
A: He wrote it.
B: Who?
A: *Who?* He was one of the Wilburys.
B: Oh, right. I know who you mean.
A: *Pretty Woman.*
B: (Purrs ala Roy Orbison.)
A: Mercy.

Hand It Over

A: Excuse me.
B: Yes?

A: I think that's mine.
B: What? No, I don't think so.
A: It absolutely is.
B: I believe you're mistaken.
A: Are you kidding me?
B: No. I'm serious. You're wrong.
A: Let me see it.
B: No.
A: I can tell.
B: I'm not giving you this.
A: Hand it over.
B: Look, I'm not sure what's going on, but this is mine, and I'm not giving it to you.
A: You're unbelievable.
B: And you've got a lot of nerve.
A: Give it here.
B: Hey.
A: Hand it over.
B: Help.

How Dare You?

A: How Dare You?
B: Oh, please.
A: Who do you think you are?
B: Who do you think you are?
A: Not someone who's going to put up with that.
B: Someone who's way too big for their britches.
A: I'm warning you.
B: What?
A: Don't think you can get away with that kind of—
B: What are you gonna do about it?
A: I beg your pardon?
B: I said, "What are you gonna do about it?"

A: Are you insane?
B: What do you think?
A: I think you're a lunatic.
B: Could be.
A: And someone who needs to be put in their place.
B: By you? Try it.
A: I'm telling you I won't stand for this.
B: Then do something about it. Don't just run your mouth like a little—
A: SHUT UP!
B: Do yourself a favor and walk away right now.
A: Do not follow me.

Homophone

A: Carol is a homophone.
B: No, she's not.
A: What?
B: She treats everybody fair.
A: Fairly.
B: What?
A: An adverb.
B: Oh . . . But she's not.
A: What?
B: Racist. I mean sexist. I mean prejudiced.
A: What?
B: She's not afraid of gays. That's the literal meaning, right?
A: Who?
B: Carol.
A: Oh. No, carol is a homophone. Two different words that sound alike but have different meanings.
B: So?
A: Nothing. That's just why there was confusion.
B: I just misheard you.
A: No, I mean the first confusion.

B: Whatever.
A: When I said I liked that carol, you thought—
B: Boring.

I Never Saw This Coming

A: I Never Saw This Coming.
B: Really?
A: Not at all.
B: I did.
A: You did?
B: Clear as a bell.
A: Not me.
B: What can I tell you?
A: So, it was fate?
B: No, we made it happen.
A: Well, there's that, I guess.
B: Indeed.
A: You saw this coming?
B: From the very beginning.
A: Well, you've got one on me there.
B: Cold comfort.
A: I suppose.
B: Sure.
A: And here we are.
B: Here we are.
A: How did this happen?
B: Just lucky I guess.

I'm In

A: I'm in.
B: I'm in.
A: Me too.
B: Let's do it.
A: Absolutely.

B: Why not?
A: Absolutely.
B: I mean, why not?
A: Exactly.
B: Right?
A: Why not?
B: Exactly.
A: I'm in.
B: Me too.
A: Let's do it.
B: No question.
A: No doubt about it.
B: Let's do it.
A: I'm in.
B: This is gonna be great.
A: Absolutely.
B: Wow.

Let's Start Over

A: Let's start over.
B: Again?
A: Is that okay?
B: You're the boss.
A: Thank you.
B: Let's just do this.
A: I just want to make sure we get this right so there aren't any mistakes down the road.
B: Maybe you better write it down.
A: Good idea. Thank you. So, you "didn't see nothing."
B: Anything.
A: Excuse me?
B: Don't make me sound stupid.
A: My apologies. You "didn't see anything."
B: Right. Nothing.

A: Good.
B: Good. Are we done?
A: Almost. I want to make sure there's no confusion when you get hauled into court.
B: What?
A: This way I'll be able to testify to what you told me on the spot.
B: Wait a second.
A: No, this way, it'll be clear when they press you on what you saw . . . or didn't see.
B: Nothing.
A: Anything.
B: Okay.
A: For example, if they say, "It was a six foot, six guy with a green mohawk," you won't be called by the prosecution to verify that.
B: Right.
A: Cause you didn't see anything.
B: Like I said.
A: Or if they say it was a tall skinny kid with Chuck Taylor's, baggy shorts, and a Knicks jersey—
B: That could be anybody—
A: —with a yellow, European bicycle cap worn backward. . .
B: Sounds like you have an idea who it was.
A: You won't testify that he wasn't there.
B: Screw you.
A: Thanks for clearing that up. I think that's all we need.
B: Wait a minute. Let me think.

Proverbs 9:15

A: I'm back.
B: I see.
A: Like a bad penny.
B: The proverbial bad penny.
A: "And, like a bad penny ye shall return from whence ye came."
B: Ha.

A: Proverbs . . . 9:15.
B: 9/15?
A: As I remember.
B: I remember 9/15.
A: The Ides of September.
B: Exactly.
A: "Try to remember. . ."
B: Don't.
A: What?
B: Don't do that.
A: Sing?
B: That. Don't do that.
A: Okay.
B: Thank you.
A: I'm back.
B: I see.

You Say Potato

A: You did extremely well.
B: It's my forte.
A: As opposed to language.
B: Pardon me?
A: Unless you're speaking French, that is.
B: French?
A: Or referencing music.
B: No, not music, or French either, for that matter.
A: Then the word is forte.
B: That doesn't sound right.
A: Nevertheless, it is correct.
B: If you say so.
A: I do. And I know these things.
B: I know you do, and I believe you, but I have a dilemma.
A: Which is?

B: Which is: do I say it the way everyone else says it, in which case it'll just slide by unnoticed, or say it correctly and have everyone think I don't know how to say forte?
A: That's your dilemma?
B: Yes.
A: I suggest you opt for accuracy and not worry about what others think.
B: That's easy for you to say.
A: Well, it is, after all, my forte.

You Shouldn't Be Here

A: You Shouldn't Be Here.
B: Says who?
A: You know you shouldn't.
B: Well, here I am.
A: They won't like it.
B: They can go pound sand.
A: You can't be here.
B: And yet here I am.
A: There'll be hell to pay.
B: There often is.
A: Don't be like that.
B: Where else would I be?
A: What am I going to do with you?
B: Whatever you like, I imagine.
A: Oh, my.
B: Oh, yeah.
A: You shouldn't have come.
B: So you said.
A: You can't be here.
B: I'm not going anywhere.
A: You have to.
B: Not gonna happen.

Appendix

We live in a time when there are great resources available to curious individuals. At the time of publication of this book, the following are of particular interest to the authors and recommended for our readers.

Interview with Peter O'Toole
www.youtube.com/results?search_query=peter+o%27tool+on+charlie+rose

Rehearsal Tips from Terry Knickerbocker Studio
https://terryknickerbockerstudio.com/how-can-i-rehearse-alone-as-an-actor-do-i-need-to/

Tips on putting together a Demo Reel
www.youtube.com/watch?v=vLHDvNBVIP8

Check out Kevin Brief's online presence:
www.youtube.com/c/KevinBrief123
www.kevinbrief.com
www.imdb.me/kevinbrief

And while you're at it, check out these demo reels:
Gonzalo Menendez:
www.youtube.com/watch?v=HMgi6pmqz3c
https://vimeopro.com/justiceponder/gonzalo-menendez PW: Gonz

There are a number of online references to Day Players.
Why Day Players Are the Backbone of the Acting World by Ilene Starger
www.backstage.com/magazine/article/day-players-backbone-acting-world-12542/

What's It Like to Be a Day Player by Scott McMahon
www.dailyactor.com/acting-advice-columns/whats-it-like-to-be-a-day-player/

The Essential Guide to SAG-AFTRA Rates 2021
www.wrapbook.com/blog/essential-guide-sag-rates

108 Appendix

We also recommend you take a look at the work by the following Day Players:

GIANT (Mickey Simpson as "Sarge")
www.youtube.com/watch?v=e4ptm6F2KHQ

THE PRESIDIO (Rick Zumwalt.as "Bully in Bar")
www.youtube.com/watch?v=fOe5ig4l9tI

FIVE EASY PIECES (Lorna Thayer as "Waitress")
www.youtube.com/watch?v=6wtfNE4z6a8

SMOKEY AND THE BANDIT II (Hal Carter as "Gas Station Attendant")
www.youtube.com/watch?v=T1P0CRKY4Ss

EYES WIDE SHUT (Alan Cumming as "Desk Clerk")
www.youtube.com/results?search_query=eyes+wide+shut+hotel+clerk

Additional Reading

There are many books with much to offer in the areas of acting, stage acting, and film acting. Among them are the following:

Act: The Modern Actor's Handbook, by David Rotenberg
Acting for the Screen, by Mary Lou Belli
Film and Television Acting, From Stage to Screen, by Ian Bernard
A Practical Handbook for the Actor, by Melissa Bruder, Lee Michael Cohn, Madeleine Olnek, Nathaniel Pollack, Robert Previtio, Scott Zigler
Acting Power: The 21st Century Edition, by Robert Cohen
The Art of Film Acting, A Guide for Actors and Directors, by Jeremiah Comey
On Screen Acting, An Introduction to the Art of Acting for the Screen, by Edward Dmytryk, Jean Porter Dmytryk
Acting for the Camera: Back to One, by Peter Allen Stone
The Science and Art of Acting for the Camera, A Practical Approach to Film, Television, and Commercial Acting, by John Howard Swain
For more Open Scenes by the authors (and others), go to www.opensceneacting.com
A quick Google search reveals the following additional Open Scenes:
www.liveabout.com/open-scenes-for-acting-practice-3938469
https://sites.google.com/a/fergflor.org/mccluer-theatre/advanced-chemistry-h/open-scenes
http://reelacting.weebly.com/contentless-scenes.html
https://rethinkcinema.com/Scriptpages.pdf

Index

Adams, Amy 52
Adler, Stella 17
Auburn, David 79; *Proof* 79–81

Beatles, The 62
Breakdown Services 49
Brief, Kevin 48, 50, 51

Casting Director 50
Chekhov, Anton 68, 70; *The Cherry Orchard* 66, 68, 72
CSI 60

Day Player 15, 48
Demetriou, Natasia 39
Dramatic Action Defined 8
Duque, Manuel 67

Emotional Packing in Acting 40

Gender Pronouns 34

Ibsen, Henrik 7

Kushner, Tony 82; *Angels in America* 67–82

Law and Order 60
Lewis, Daniel Day 65

Meisner, Sanford 17
Mentalist, The 60

NCIS 60
Neeson, Liam 39
NYPD Blue 60

Pitt, Brad 52
Positive Energy in Acting 33
Pratt, Chris 39

Sides Express 49
Sides: History of 51
Shanley, John Patrick 73; *Doubt* 66, 73
Stanislavsky, Konstantin 7, 15; Technique of *Magic If* 15
Strasberg, Lee 17
Streep, Meryl 65

Trigger Warnings 65

Vogel, Paula 7; Style of writing in *How I learned to Drive* 7

Williams, Tennessee *Kindness of Strangers* 19